IMAGES
of America
RIO LINDA
AND ELVERTA

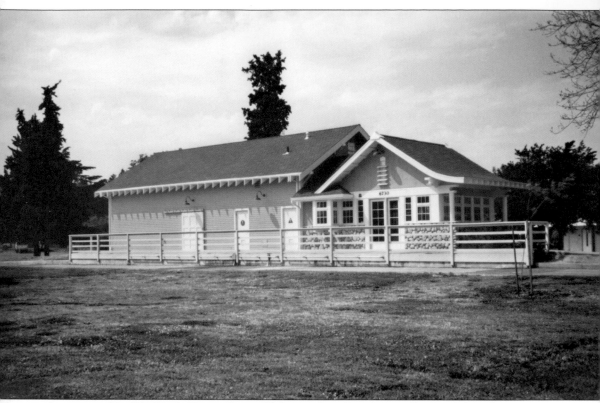

As proposed by Rio Linda Elverta Lions Club president Ray Antonelli, the club took on a major long-term project to benefit the community—rebuilding the Sacramento Northern Railway train station on Rio Linda's Front Street. The project, chaired by Roger Mitchell, took almost a decade to complete while funds were raised to pay for architectural drawings and construction. Every effort was made to reconstruct the depot and attached freight shed just as it had been built in the early years of the community, but some alterations had to be made for it to be used as a public facility. A ribbon-cutting ceremony was held on Friday, June 18, 2004, to celebrate the completion of the project. (Courtesy author.)

ON THE COVER: Participants from Elverta and Rio Linda gather for this Days of '49 parade photograph. Young and old alike got into the action and dressed as authentically as possible. (Courtesy Florence Ross Wilhoite.)

IMAGES
of America

RIO LINDA
AND ELVERTA

Joyce Buckland

ARCADIA

Published by Arcadia Publishing
Charleston SC, Chicago IL, Portsmouth NH, San Francisco CA

Printed in the United States of America

Library of Congress Catalog Card Number: 2005937817

For all general information contact Arcadia Publishing at:
Telephone 843-853-2070
Fax 843-853-0044
E-mail sales@arcadiapublishing.com
For customer service and orders:
Toll-Free 1-888-313-2665

Visit us on the Internet at www.arcadiapublishing.com

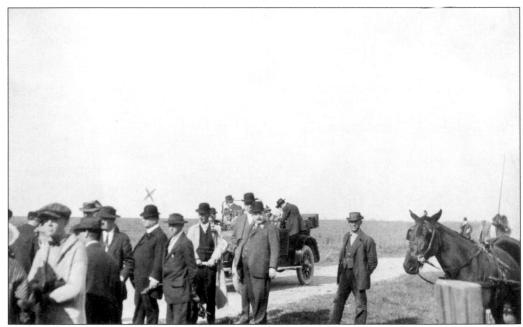

During the early days of the settlement of Rio Linda, spring weather brought golden fields of California poppies. When the poppies began to bloom, large numbers of people rode the Sacramento Northern Railway trains to Rio Linda to see the flower-covered fields. The Poppy Festival became an annual event, with people bringing picnic lunches and holding various social functions. This photograph shows the then governor of California, Hiram Johnson (with the "X" above him), and associates making a tour of the area to see the poppies. Governor Johnson later became Senator Johnson. (Courtesy Eloise Wagner collection.)

CONTENTS

ACKNOWLEDGMENTS

This book is dedicated to Marge Krans, who came to the area in 1946 when she married Jim Krans and the couple was just beginning a life together in the poultry business. Marge had a longtime interest in family and local history, and she spent countless hours collecting photographs, news articles, antiques, and whatever else she could find on the subject. Her camera went everywhere with her, and people just had to tolerate her taking photographs, whether it was at the grocery store, a restaurant, the doctor's office, or anywhere else she happened to be. Her many, many scrapbooks provided much of the material for this book. As her daughter, I will be forever grateful to her for the interest she instilled in me and the heritage she preserved for us and future generations.

In addition to Marge's scrapbooks, I would like to extend special thanks to several people who helped make this book possible. I am especially appreciative of my sister, Margaret Posehn, who shared many photographs, researched numerous details, and offered advice when asked. Margaret is also an avid historian and spends countless hours digging out the bits of local history that have been long forgotten. And thank you to my brother-in-law, John Posehn, for sharing his knowledge of our history.

Special thanks also go to my dear friend and genealogy buddy, Nancy Morebeck, who shared photographs and documents, and offered encouragement and suggestions when needed.

I am grateful to the many families and descendents of those families who have so generously shared their photographs with the Rio Linda/Elverta Historical Society and with me: Noma

Chapman Gerolamy and her daughter Lana Anderson shared the Sam and Nina Chapman collection; Irene Johnson Fallon shared Alyce Johnson's photographs; Harry Wagner donated the photographs of his mother, Eloise Wagner; Bob Bastian; Kenna Wait Boyer; Virginia Sisler Chapman; Bob Chatterton; Tom and Ella Mae Douglas; Melville E. Driver Jr.; Wilma Dyer; John Lee Ernst; Carol Geiger Fanchar; Sharon Freitas; Erwin Hayer; Pat Ford Hillman; Norma Horrell; Bernice Lux; Roger Mitchell; Dorothy Ross Morebeck; Violetta Brown Odell; Carol Schulte Sherrets; Leone Thorne; Frank Weckman; Judith Cox Whipple; Florence Ross Wilhoite; Vi Williams; Randy Wooten; and our recently departed friends Wilbur Donsing, Ruby Harris, and Helen McKenzie.

Special appreciation goes to my husband, Maynard, who encouraged me when I was down, offered wonderful suggestions, and helped wherever it was needed, especially when it came to meals and housework. Thank you for your patience!

INTRODUCTION

The settling of the Rio Linda and Elverta areas began in the 1850s. The land was part of the Rancho del Paso property, purchased by Samuel Norris for $8,000 in 1849. One of the main emigrant roads crossed the Rio Linda–Elverta district and passed through what is now the Rio Linda town site. This was the Nevada Road, which crossed the Sierra Nevada Mountains, passed through the Roseville and Rio Linda areas, and into Sacramento.

The Star House, or Star Hotel, built by E. M. Pitcher and his wife, Jane, and the Harmon House were both located in what later became Rio Linda. They were favorite stopping places for those traveling the Nevada Road.

Early emigrants to the Elverta area were the Strauchs, Keithleys, Chattertons, Drivers, Wolfes, and Scheidels. They had large grain ranches as long ago as the mid-1850s.

The legality of Norris's claim on the Rancho del Paso property was challenged in court several times between 1851 and 1859. Norris won the battle, but was so in debt to his lawyers, James Ben Ali Haggin and Lloyd Tevis, that he lost the rancho to them. Haggin and Tevis used the land as pasture for cattle, horses, and 20,000 sheep.

In 1905, the Northern Electric Railway started construction of the rail line from Chico to Sacramento. Charles M. Basler purchased 1,400 acres in 1907 in what was to become the Elverta subdivision. The town of Elverta was named for Elverta Dike, and a post office was established in 1908.

In 1910, Haggin and Tevis sold Rancho del Paso to the Sacramento Valley Colonization Company of Phoenix, Territory of Arizona, a subsidiary of the United States Farm Company of St. Paul, Minnesota, for $1.5 million. In 1911, the Sacramento Valley Colonization Company sold 1,493 acres to Alvah E. Roebuck, of Chicago, Illinois. Roebuck called this property the Rio Linda Colony and subdivided the land into the town of Rio Linda. Roebuck was the cofounder of Sears Roebuck.

Alvah Roebuck's efforts to colonize Rio Linda failed, and the land came under the ownership of the Interurban Acres Land Company (which may have been connected to the United States Farm Company). This company then changed its name to Sacramento Suburban Fruit Lands Company.

The property purchased by the Sacramento Suburban Fruit Lands Company amounted to 12,500 acres and included all of Rio Linda and parts of what is now North Highlands and McClellan Park. The Fruit Lands Company subdivided the property into smaller tracts and laid out the town site of Rio Linda on both sides of the Northern Electric Railway track. These tracts of land were advertised extensively throughout Minnesota, Wisconsin, Iowa, and the Dakotas. The company published booklets touting the fertile soil suitable for growing all fruits and gardens, abundant water, wonderful climate, and the convenient transportation by rail and road to Sacramento, San Francisco, and other regions of California. The first tract in Rio Linda was sold in 1912, probably to Michael and Lizzie Blocher. Others soon followed.

The first families planted fruit orchards and gardens, and had cows and chickens as well. The Sacramento Suburban Fruit Lands Company built a $600 one-room community hall, where a school opened. In 1914, the Rio Linda School District was formed. Before this, local children attended school at Elverta's Lincoln School or Robla School. High-school students rode the Northern Electric trains to Sacramento to attend Sacramento High School.

By 1918, it became apparent that the profitable production of fruit on a commercial basis was impossible because of the layer of hardpan just under the soil in the Rio Linda area. As a result, many residents turned to the poultry business. By 1919, annual egg sales in the Rio Linda and Elverta areas amounted to $40,000. The Rio Linda Poultry Producers' Association was formed in 1920, and its warehouse was completed in 1921. This was also the year electrical service and a telephone exchange arrived in Rio Linda.

In 1923, the Rio Linda Fire District was formed. Elverta also formed a fire district in 1923, but it disappeared and re-formed in 1944. Both fire districts played a major roll in the communities, and they merged into one district in 1987. In 1990, this new district merged with American River Fire Protection District, and an era of local history ended.

The communities of Rio Linda and Elverta flourished and grew. In 1937, the Sacramento Air Depot opened and many local residents went to work there. Sacramento Air Depot became McClellan Field in 1939 and McClellan Air Force Base in 1948. Growth at the base brought a significant number of new residents to the area, and people learned to enjoy the rural area.

The poultry industry thrived until the late 1960s and early 1970s. By then, almost every poultry ranch in the area had shut down. Rio Linda and Elverta became bedroom communities, with residents who worked out of town.

Residents of Rio Linda and Elverta still cherish their rural neighborhood and are reluctant to see it disappear. There is a strong spirit of community, and efforts continue to keep it that way.

One

BEFORE ELVERTA AND RIO LINDA

The first known resident of the area that was to become Rio Linda was E. M. Pitcher. He came to the area in the late 1840s with his wife, Jane, and built the Star House (or Star Hotel) on Nevada Road. This was a favorite stopping place for those traveling to and from Sacramento. The Star House was located at what is now Sixth Street and Elkhorn Boulevard in Rio Linda. The Pitchers had seven children. E. M. Pitcher traveled to New York in the mid-1840s to bring the famous stallion, John Nelson, to California. While making the overland trip across the Isthmus of Panama, Pitcher contacted Panama fever and died not long after his return. He was buried in a small cemetery with 13 graves, located south of a large oak tree near Sixth Avenue between K and L Streets in Rio Linda. (Courtesy Margaret Posehn.)

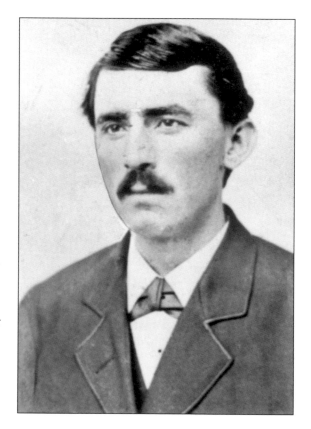

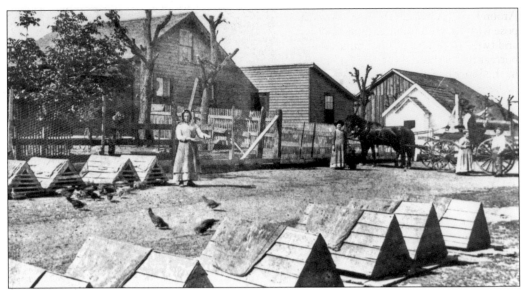

David Strauch left Germany in 1858, landed in New York, and then came to California. He first settled in what is now the Robla area, and in 1862, he purchased land in the town currently known as Elverta. Strauch kept adding to his property until he had 1,100 acres, where he had a large dairy and raised grain and hay. There were 13 children born to David and his wife, Magdalena (Miller). This photograph of the ranch shows Emma Strauch feeding the chickens, Henrietta (Gerhardt) Strauch standing by the horse, Charles C. Strauch standing on the wagon, and Annie and Gustave Strauch standing by the wagon. (Courtesy Bernice Lux.)

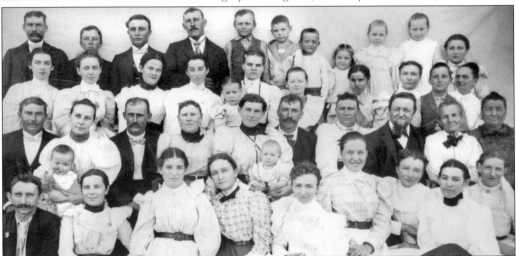

The Strauch family, pictured here in 1898, from left to right, are (first row) three unidentified, Rose Strauch, Louise S. Strauch, Emma Kurtz, Lena S. Strauch, and two unidentified; (second row) Gustave Strauch, Mrs. Aehler and baby, August Wolf, Annie May Strauch, Helene (Wolf) Strauch and baby Lillian Strauch, Charles Strauch, Emma (Steinmiller) Strauch, Victor Fred Strauch I, Mrs. Harms, and Mrs. Sermonet; (third row) Ann Sermonet, Grace Sermonet, Alvina Kurtz, unidentified, Lillie Olbach, unidentified, Belle Colburn, unidentified, Emma Strauch, Victor Fred Strauch II, and Mrs. Colburn; (fourth row) Rudolph Strauch, Herman Parath, George Strauch, John J. Wolf, Walter Strauch, Carl Olhler, Elmer Strauch, Lottie Strauch, Alice Strauch, Ethel Colburn, and Flora Strauch.

Around 1905, Charles and Lena Strauch pose with their children, Lillian, David, and twins Ruby and Pearl. Charles was born at the Strauch Ranch and educated in the Lincoln School District, where he later served on its board of trustees. He married Lena C. Wolfe, also a native of Sacramento County, on June 6, 1897, and they had seven children altogether. Charles ran the family farm, which included a dairy, and engaged extensively in stock raising. Lena was the daughter of Joseph and Mary (Webber) Wolfe but was only three years old when her parents died. She was reared by her grandmother, Elizabeth Webber, a native of Germany and a pioneer of 1849. (Courtesy Bernice Lux.)

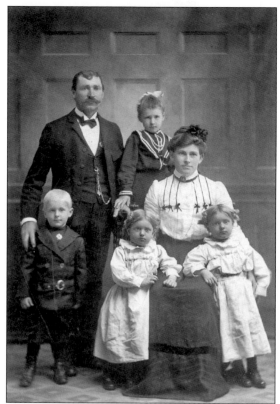

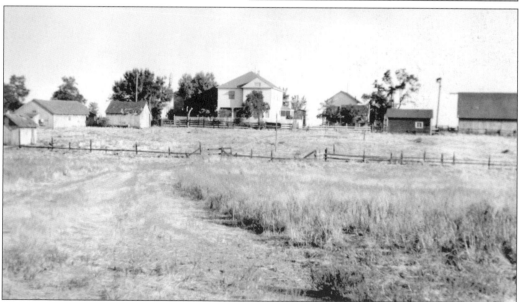

The Strauch Ranch, as it appeared in 1938, was located east of Levee Road, roughly midway between Elverta Road and Elkhorn Boulevard. Strauch Road was named for the family, but the name was misspelled and the yet-to-be-corrected sign still reads Straugh Road. There was even a Strauch Post Office for six months in 1895, named for the postmaster, Victor F. Strauch. (Courtesy Bernice Lux.)

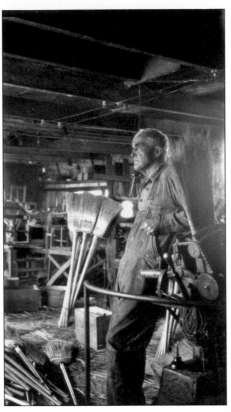

Walter W. Strauch was the eighth child of Victor F. Strauch and Emma Steinmiller, and the grandson of David and Magdalena Strauch. He married Ethel Burres, who, at that time, was postmistress in Riego, and they had six children—four sons and two daughters. Walter farmed and later raised turkeys. During the last 30 years of his life, he was a broom maker. Walter started out working for the A. J. Pallady Broom Factory and later bought the business for himself. He even raised his own broom corn for many of those years. Walter also served as the fire chief of Elverta for several years. (Courtesy SAMCC.)

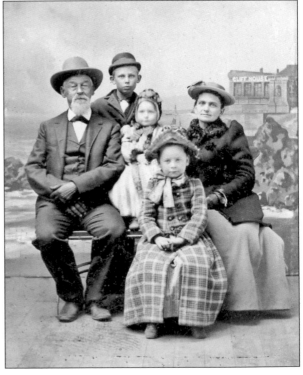

The James A. Colburn family had this photograph taken in Sutro Heights, San Francisco, while on a visit to the city. James A. is seated next to Clarence Thomas, his stepson; Ethel and Belle, his daughters; and Violetta (Stillwell) Colburn, his second wife. Clarence was Violetta's son from her first marriage to Albert Thomas. James also had two daughters from his first marriage to Charlotte French— Jewetta and Hattie Colburn. (Courtesy Violetta Brown Odell.)

James A. Colburn had several occupations during his lifetime. He started out as a cooper in New Hampshire. Upon his arrival in Sacramento in 1852, he worked in the hay business briefly, then it was on to freighting from Sacramento to the mines. He next became the proprietor of the Fifteen Mile House on the Nevada Road in Placer County. In the 1860s, James was proprietor of the pioneer hotel of St. Charles in Sacramento. Then in 1869, he turned his attention to the sheep industry. By 1870, had a ranch of 2,200 acres in both Sacramento and Placer Counties. (Courtesy Violetta Brown Odell.)

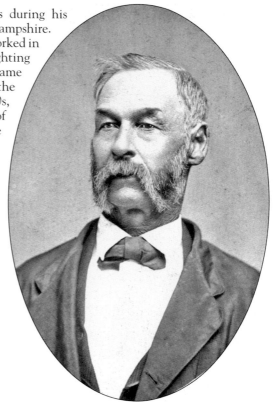

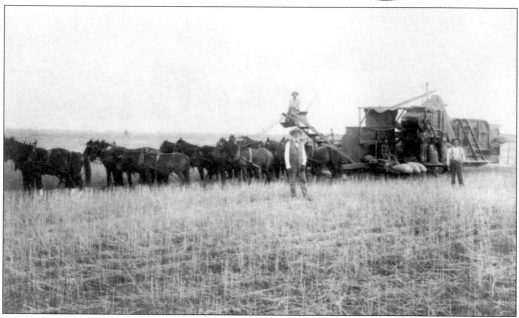

With a team of 16 horses pulling the harvester, James A. Colburn stands proudly in front of the horses around 1880. The other two men are not identified, but the boy sitting above the sacks of grain is Clarence Thomas, James Colburn's stepson. The Colburn ranch was in Elverta at the end of Pallady Road. (Courtesy Violetta Brown Odell.)

In 1875, August Wolfe, the son of Joseph and Mary (Webber) Wolfe, was born in what became known as Rio Linda. He married Annie May Strauch on February 21, 1900, and they had three children—Mary, Cecelia, and Richard Victor. August and Annie had a ranch in Rio Linda between Levee Road and West Sixth Street, north of Elkhorn Boulevard (where Taylor Fertilizer Company is currently located). The ranch had dairy cows and chickens, and they grew their own vegetables. When the couple first married, August supplemented their living by hunting ducks. (Courtesy Kenna Wait Boyer.)

On January 1, 1902, August Wolfe's daughter Mary was born on the family ranch. In 1924, she married Charles Scheidel. Charles and Mary had three children: Frances, LaVerne, and Wesley. Mary lived to be 99 years old. As the oldest resident of the Rio Linda and Elverta communities, Mary was chosen to cut the ribbon for the grand opening of the new McDonald's in Rio Linda in 1995. (Courtesy Bob Chatterton.)

On April 16, 1884, Albert Jacob Scheidel, the second child of Jacob and Pauline (Wuster) Scheidel, was born in the area. His younger brother was Charles Scheidel, who married Mary Wolfe. Albert attended Lincoln School and grew up working on his father's farm. He married Florence Christenson on April 28, 1917, and they had four children: Helen, Shirley, Patty, and Jack. Albert raised grain and hay on a 400-acre farm. In 1947, he began growing rice with his son-in-law Ross McKenzie, Helen's husband. (Courtesy Helen Scheidel McKenzie.)

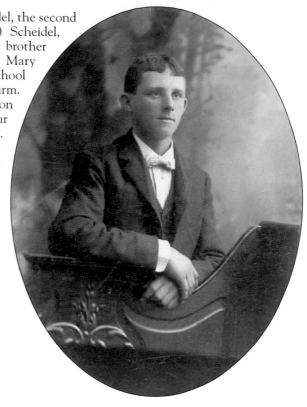

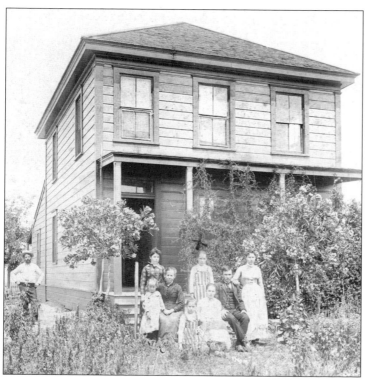

Pictured is the Harms family home in Elverta. Charles Harms came to California in the early 1850s and settled in the northern part of Sacramento County. He had one daughter, Dora, by his first wife, Elizabeth. When Elizabeth died, Charles married Lena Dexheimer, and their children included Lena (who married John Henry Nicolaus), Henry (who married Elizabeth Martin-Brown), Elizabeth (who married Charles Stahl), Anna (who married Carlyle Wait), Sophia (who married Frederick Dosch), and Phillipina (who married Francis Miron Poole). (Courtesy Kenna Wait Boyer.)

Edgar Chatterton was the sixth and last child of James and Kate (Moore) Chatterton, who came to this area in the 1850s. Edgar married Olive Waite on June 19, 1918, and had two children, Elsie (pictured here) and Robert James. The Chattertons were farmers and had a cherry orchard on Cherry Island between the two forks of Dry Creek. Chatterton's Grove, a popular picnic area among the oak trees, was located on the family ranch. (Courtesy Bob Chatterton.)

Carlyle Wait came to California from Boone County, Iowa, where he was born in 1868, and settled in the Elverta area. He married Anna Harms in 1894 and they had six children—Alvin, Leland, Mildred, Elwood, Kenneth, and Lawrence. Carlyle Wait raised grain and hay on his ranch. (Courtesy Kenna Wait Boyer.)

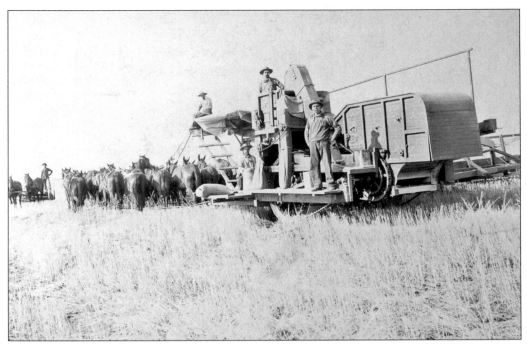

Harvest time meant large teams of horses or mules and big harvesters. Carlyle Wait stands on the side of his harvester with his crew. (Courtesy Kenna Wait Boyer.)

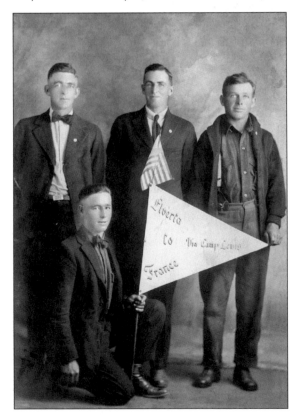

Many of the local lads served in World War I. Pictured here are Irwin Beattie, Edgar Chatterton, Charlie McKinnon, and Alvin Wait (kneeling), shortly before they left to serve their country. The banner reads "Elverta to France via Camp Lewis." (Courtesy Kenna Wait Boyer.)

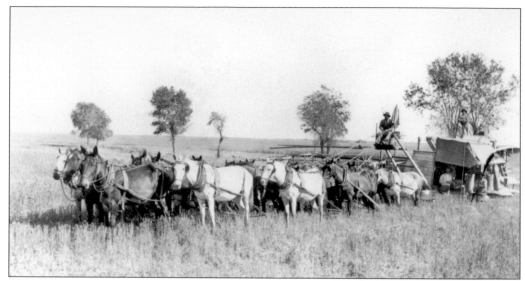

The Chatterton family ranch was located on what is now Elverta Road and was considered to be on the fringe of Elverta and Antelope. They raised grain and hay, like many of the other farmers in the area. This photograph shows James Chatterton seated behind his team and pulling the harvester. (Courtesy Bob Chatterton.)

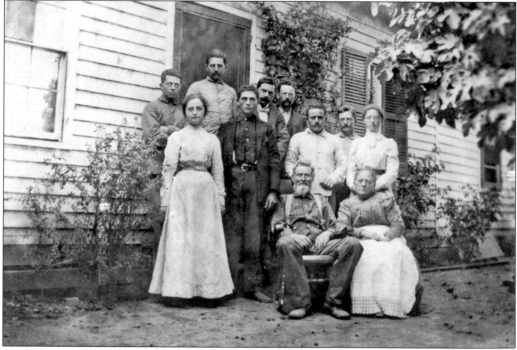

In the early 1850s, Elisha Sample Driver was another immigrant who arrived in California from Iowa. His family ranch was located in Antelope. In addition to raising grain and hay, he had a dairy and raised stock. Elisha married Mary Forsyth in 1860, and they had 12 children. Pictured here, from left to right, are (first row, seated) Elisha and Mary Driver; (second row) Clarence, Birdenia, Grant, Lester, William, Philip, Benjamin, Charles, and Abigail. (Courtesy Melville E. Driver Jr.)

Two

TWO TOWNS EMERGE

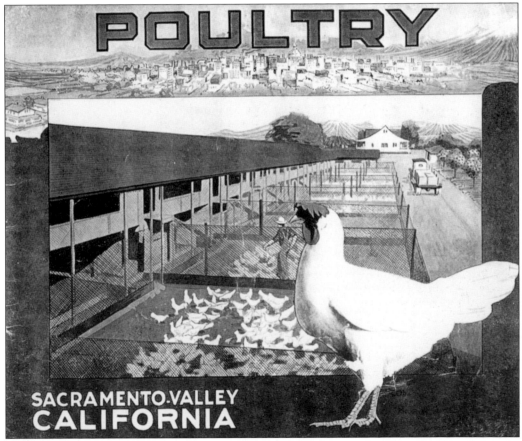

This was perhaps the most enticing cover of the five known booklets distributed by the Sacramento Suburban Fruit Lands Company. The company made some amazing claims and had attractive photographs, but many of the new settlers to Rio Linda and Elverta were soon disappointed when they learned of the hard pan that was under much of the area.

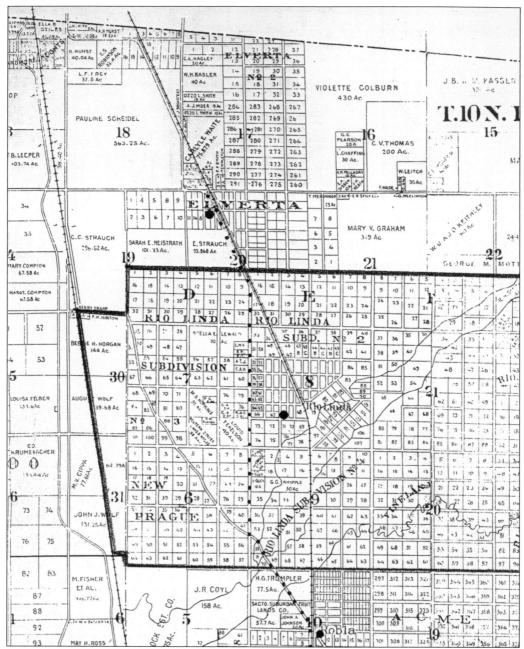

The layout for the townships of Elverta and Rio Linda is shown in the map above. The Sacramento Northern Railway tracks cut through the middle of both communities, and the Western Pacific tracks ran along the west side. Elverta and Rio Linda met on what is now U Street, but there was no distinct boundary between Elverta and Antelope. Rio Linda extended to what is now Watt Avenue in North Highlands and south to A Street (now Ascot), where it is bounded by Sacramento. The major landowners at that time are listed above. (Courtesy Margaret Posehn and SAMCC.)

This is one of the numerous photographs used to entice people to the area. Oak trees were the most common ones found in the area, especially along the banks of Dry Creek. (Courtesy Pat Ford Hillman.)

Orchards were a drawing feature of the area, and many photographs were dispersed showing the fine trees and fruits. The fertile land along Dry Creek did support some beautiful orchards, as seen in this photograph of Chatterton's cherry orchard on the island between the forks of the creek. Located south of Chatterton's on the same island was another prosperous cherry orchard, owned by John Mott. Many olive orchards also flourished in the area. (Courtesy Bob Chatterton.)

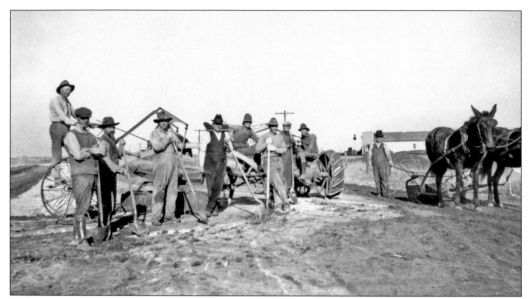

As the number of settlers grew in the region, work began in earnest to construct roads. Mules and horses worked beside the tractors with this work crew, pictured taking a break to pose for the photographer. Sam Chapman was one of the major forces behind the road construction. (Courtesy SAMCC.)

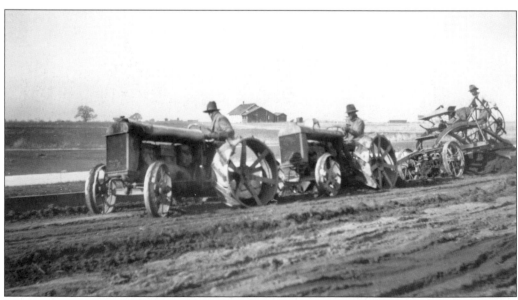

Like tractors in a parade, the men work on road construction. (Courtesy SAMCC.)

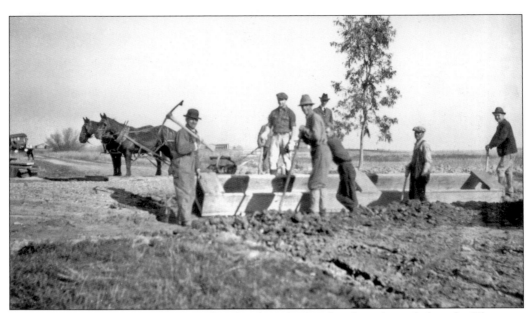

Much of the road-building work had to be done by hand with picks and shovels. The men constructed forms for the cement. It was labor-intensive work, but well worth the effort as it meant fewer problems with getting stuck in the mud during rainy weather. (Courtesy SAMCC.)

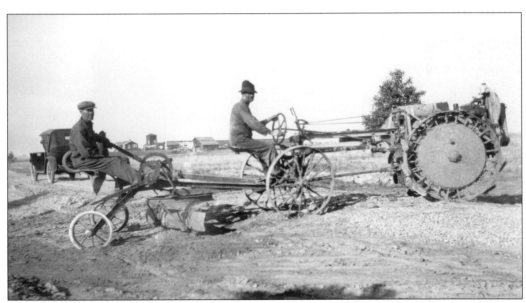

It took two men to operate this grader, which leveled the ground for the new roads. Though primitive by today's standards, the grader did the job, as evidenced by the many good roads in Rio Linda and Elverta during the early days. (Courtesy SAMCC.)

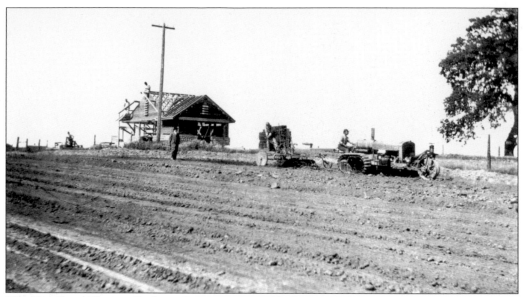

The Northern Electric Railway Company timetable for December 18, 1910, listed stops at Dry Creek, Elverta, and Riego. By March 30, 1914, the timetable listed Rio Linda instead of Dry Creek, and construction of the train station had begun. Front Street was also under construction at this time. (Courtesy Wilbur Donsing.)

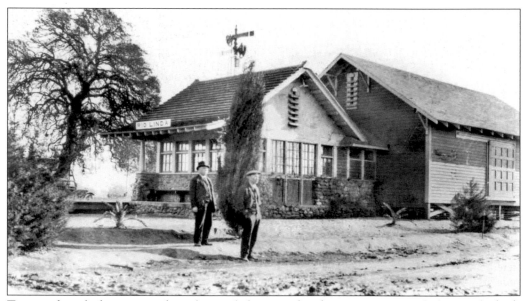

Two unidentified men stand in front of the completed train station and the newly built freight shed attached to the station. In addition to transporting passengers, the trains brought goods to the early settlers and provided for shipping of local fruits to market. (Courtesy California State Library.)

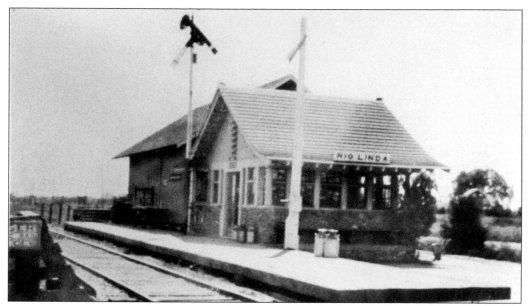

Here is another view of the Rio Linda train station and freight shed with its platform. The Sacramento Northern Railway provided a valuable service to the residents, including transportation for high-school students, who had to travel to Sacramento just to attend class. (Courtesy Irene Johnson Fallon.)

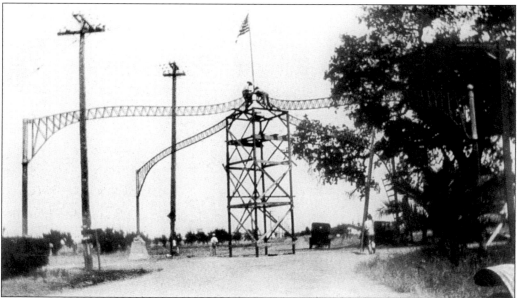

In the early 1920s, the City of Marysville decided to dismantle its seven arches. Rio Linda was offered one, and the Rio Linda Elverta Grange accepted it. In 1926, the arch was erected in Rio Linda at the intersection of Rio Linda Boulevard and M Street. It soon became a landmark for the small town and is still cherished today. Here grange members are putting the final touches on the arch. When completed, a sign with Rio Linda's name hung from the center. That sign disappeared long ago. Later, in Marysville, a movement to acquire the arches back was put into motion and Rio Linda was asked to return their arch. However, the town was not about to give it up after all these years. (Courtesy Tom and Ella Mae Douglas.)

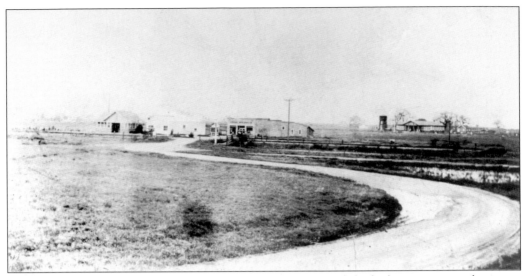

This 1921 view of Rio Linda shows just how sparsely populated the little town was at that time. Here the train station is seen with a garage and Woodward's store slightly behind it. In the distance is the Rio Linda Grammar School, constructed in 1917. (Courtesy Wilbur Donsing.)

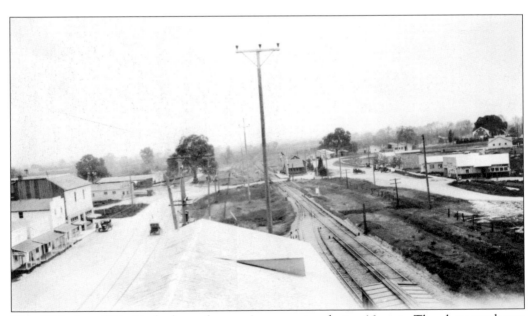

This 1937 view of Rio Linda shows the town's progression during 16 years. The photograph was taken by Wilbur Donsing from the top of the Rio Linda Poultry Producers Building, facing south toward the train station. On the left are the buildings that housed Stenberg and Johnson's store, Norbyrhn's Lumber, McVey's Barber Shop, and Johnson Electric. To the right are Best's Garage, the Rio Linda Fire Department station, and Russ Grocery. (Courtesy Wilbur Donsing.)

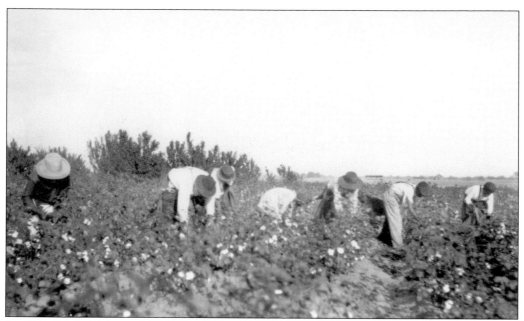

In 1926, M. L. Nelson planted cotton on his land along A Street in Rio Linda. C. McCall, a cotton expert, formerly of Florida but relocated to Sacramento, inspected the cotton and pronounced it a very fine crop, but not thinned enough. He stated that 16 bolls to the plant was a good crop, and that this field averaged better than that. (Courtesy SAMCC.)

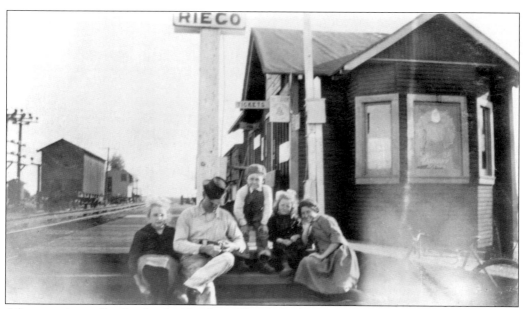

After stopping in Rio Linda, the Northern Electric Railway trains traveled north to Elverta and then Riego. For a brief period, there was also a stop at Ardmore, but that area did not develop. Riego was an agricultural area that prospered enough to have a post office from July 3, 1908, to March 15, 1919, and this train station. (Courtesy Hans Krueger collection.)

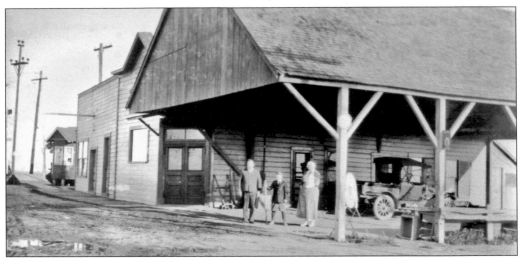

The Riego area flourished in the 1920s and 1930s, with a large number of Japanese families living in the area and growing strawberries. This is the Riego Inn owned by Louis Goetz and his wife, Emma Kirchner. Although it was called an inn, it appeared to be more of a tavern than a hotel. The general store and post office were located in the buildings to the left and the last building was the Riego train station. Pictured here, from left to right, are Louis Goetz, unidentified, and Emma Michel. (Courtesy Hans Krueger collection.)

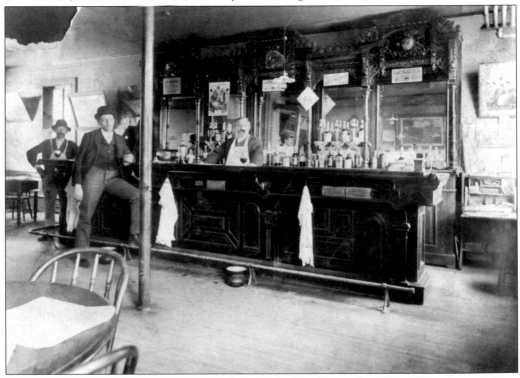

Inside the Riego Inn, Louis Goetz stands behind the bar during the 1920s. The other two men are unidentified. Goetz was a native of Germany and a retired baker. By the end of the last century, Riego still had a store, a lumberyard, and a small number of residents. It never developed into a community like Elverta and Rio Linda. (Courtesy Hans Krueger collection.)

Three

EARLY RESIDENTS

Lizzie and Michael Blocher are believed to be the first residents of the new town of Rio Linda, arriving in late 1912. They were Devout Brethren, or "Dunkards," who came from Devil's Lake, North Dakota, and settled on five acres south of K Street near the railway tracks. Michael Blocher, a reverend, served as pastor for the Brethren church, which met in the community hall. The couple had no children. (Courtesy Sam and Nina Chapman collection.)

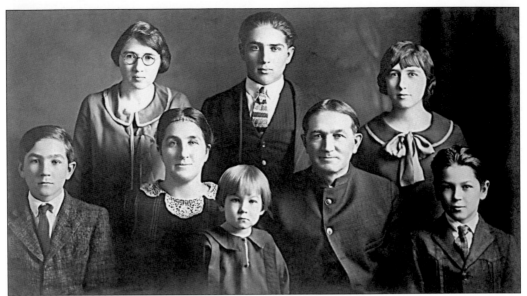

The Whipple family arrived in Rio Linda in September 1913 and settled on 40 acres they purchased from Mrs. Briggs of Hagginwood. Alfred Whipple leveled land and plowed and graded for other residents. The Brethren church was organized in his home. This February 14, 1925, photograph of Alfred and Golda Whipple's family, from left to right, includes (first row) Harry, Golda, Eldora, Alfred, and Lee; (second row) May, Otis, and Naomi Whipple. (Courtesy Judith Cox Whipple.)

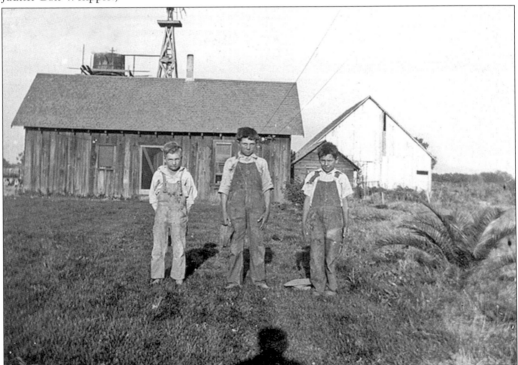

Sometime before 1924, the three Whipple boys—Otis, Harry, and Lee—were photographed at the Whipple home. (Courtesy Judith Cox Whipple.)

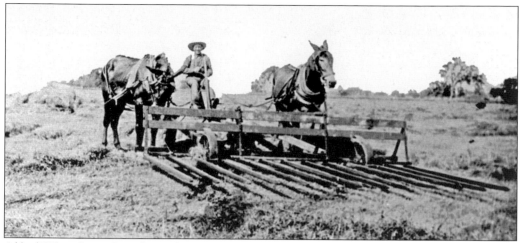

Alfred Whipple, with mules and a buck rake, worked the ground for many of the local residents. The mules pushed the rake, rather than pulling it. Alfred kept daily diaries from 1909 until 1974. Some days, his wife, Golda, made the entries for him. Four decades of those diaries (from 1909 to 1949), along with numerous family photographs, have been published by Judith Cox Whipple. (Courtesy Judith Cox Whipple.)

This 1940s photograph shows the small dam built across Dry Creek by Roy Hayer. Alfred Whipple, with the help of his sons, originally built the first dam across Dry Creek in 1929, so that he could use the water to irrigate his crops. There is no known photograph of the Whipple Dam, only drawings of the design in a book published by Lee Whipple. After Roy Hayer purchased the land from Whipple, he rebuilt the dam and maintained it until his death. His son Erwin Hayer continued to maintain the dam until it was replaced with the Hayer Bridge, which spans Dry Creek in 2005. (Courtesy Marge Krans.)

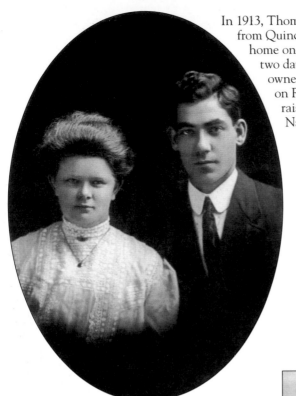

In 1913, Thomas and Elizabeth (Harrop) Ross came from Quincy, Illinois, to Elverta. They made their home on what is now El Modena Street and had two daughters, Florence and Dorothy. Tom owned and operated the T. H. Ross Garage on Rio Linda Boulevard, but the family also raised chickens and turkeys. (Courtesy Nancy Morebeck.)

In February 1911, May (Mamie) Helen Ross, sister of Thomas Ross, purchased a substantial piece of land from Victor F. Strauch. This property was then subdivided by May's new husband, Charles Martin Basler, and sold off in parcels of various sizes. After Charles Basler died in 1939, Mamie married Carl A. Rasmussen. During the mid-1930s, Mamie worked as an assistant to Katherine Kitchen, who had a regular column in *The Sacramento Bee*. By 1946, Mamie was working in the Statistical Control Department at McClellan Field. (Courtesy SAMCC.)

Nina and Sam Chapman came to Rio Linda from Ontario, Canada, in December 1913, and were active in the community. Sam was a self-employed electrical contractor, who also drilled wells for water and set up watering systems. He assisted in the construction of Rio Linda Boulevard, was an original trustee of the Rio Linda School District, and was the first master of the Rio Linda Grange. Nina was a charter member of the Rio Linda Rebekah Lodge. They had four daughters and one son: Laurene, Maurice, Helen, Edra, and Noma. (Courtesy Sam and Nina Chapman collection.)

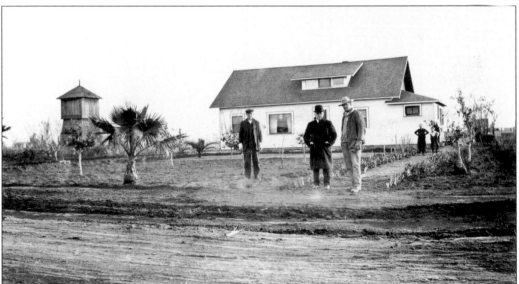

The Chapman home, built by Sam Chapman, was located on Eighth Street in Rio Linda and included a tank house, as did most of the early residences in these communities. The Chapmans also raised chickens for several years and had fruit trees. The two men standing in the path are Sam Chapman, left, and Springate Thorn, Nina's father. (Courtesy Sam and Nina Chapman collection.)

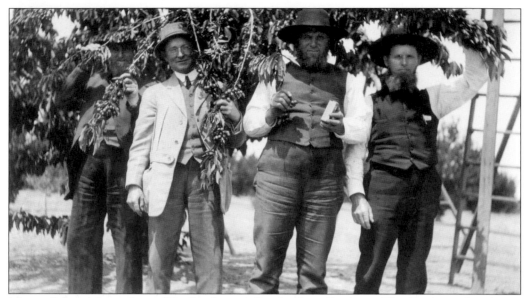

Many of the early settlers in Rio Linda were Dunkards or Brethren. The Brethren church was organized in the home of Alfred Whipple and met in the little green community hall, which also served as the school. Pictured here, from left to right, are unidentified, unidentified, Albert Gentry, and Louis Terkelson. (Courtesy Sam and Nina Chapman collection.)

Helen and James Reker came to Elverta in 1914 and settled along Rio Linda Boulevard. James was an immigrant from Denmark and Helen was from Sweden. They had eight children, and James worked as an electrical engineer for Pacific Gas and Electric Company (PG&E). (Courtesy Wilma Reker Dyer.)

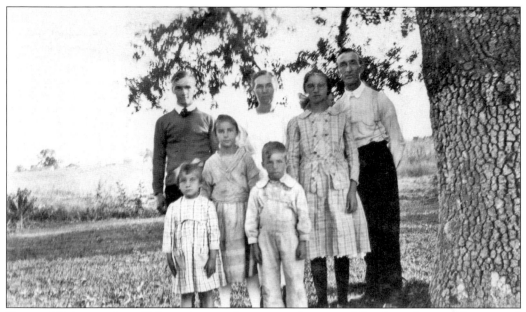

George Glick, a native of Missouri, was a farmer, mechanic, and Brethren deacon. He married Susie Whipple, also a native of Missouri, and they came to Rio Linda around 1915. The Glick family, pictured here in 1921, included five children—Dale, Thelma, Fern, George, and Dorothy. (Courtesy John Lee Ernst.)

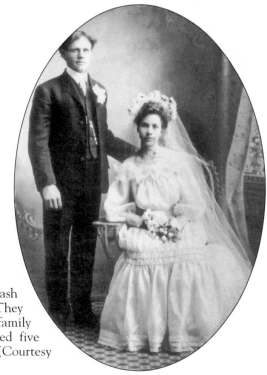

This photograph shows Daniel and Anna Nash on their wedding day in North Dakota. They came to Rio Linda with the Bonepart Harris family in September 1918. Daniel and Anna raised five children on their poultry ranch and orchard. (Courtesy Elwood and Eileen Nash.)

Marvel Harris, a native of Minnesota, came to the area in 1917, and in 1923, he married Ruby Devine in Rio Linda. They had two children and became quite active in the community. Marvel formed a partnership with Jim Devine and they provided services to local residents for many years. This photograph shows Marvel and Ruby Harris at a social function. (Courtesy Ruby Harris.)

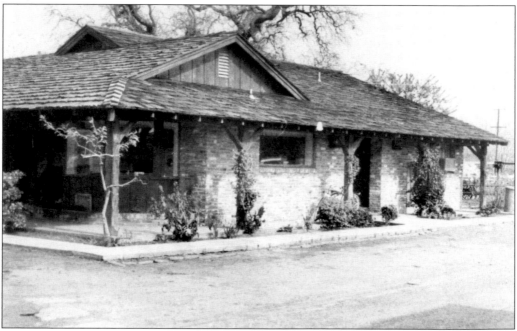

The Harris home in Rio Linda was built in stark contrast to most of the homes in the area. The rambling, old brick house, built beneath the spreading branches of a great oak tree in the front yard, had a shake roof that swept over long porches in both front and rear. (Courtesy Ruby Harris.)

James Irvine Beattie sits on the front porch of his Elverta Hatchery with his son James Jr.; Belle Colburn Beattie, his wife; and Marjorie Stahl, his stepdaughter. (Courtesy Violetta Brown Odell.)

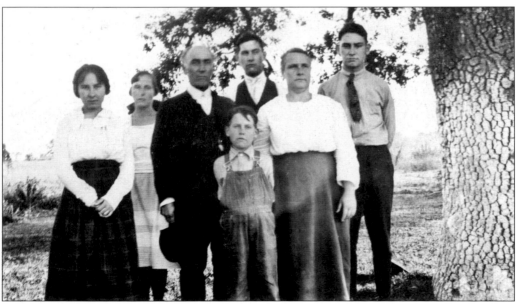

In February 1920, John and Viola Ernst brought their family to Rio Linda, where they lived on Rio Linda Boulevard. John was a minister for the Brethren church. This 1921 photograph of the Ernst family includes Mae, Lucinda, John, Archie, Joe, Viola, and George. (Courtesy John Lee Ernst.)

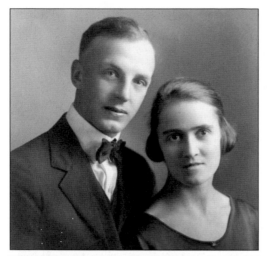

Lester Price Thorn came to Rio Linda in 1920, but returned to South Dakota to marry his wife, Grace Campbell. The couple had two children, Beverly and Lester Bruce. Les owned the first garage in Rio Linda, Thorn's Garage. He became the first fire chief of the Rio Linda Fire Department in 1923 and housed the first fire truck in his garage until the fire station could be built. (Courtesy Sam and Nina Chapman collection.)

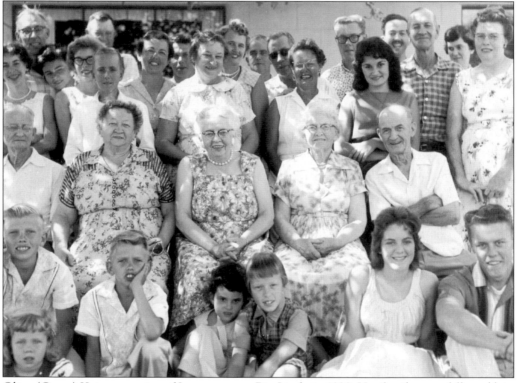

Olive (Curry) Keiser, a native of Iowa, came to Rio Linda in 1920. Her family soon followed her. She and her late husband William Keiser had four children: Richard, Mary, Jessie, and Florence, all born in South Dakota. This photograph shows Olive's three daughters and their families. Pictured, from left to right, are (first row) Ross Sullivan, unidentified girl, Wayne Sullivan, Lynn Douglas, Ruth Douglas, unidentified, and Tom Douglas; (second row) Rance Root, Mary Keiser Root, Jessie Keiser Douglas, Florence Keiser Van Voorhis, and Roy Van Voorhis; (third row) Charlotte Harvey, Karl Harvey, Noreen Van Voorhis, Deborah Emerick, Alfred Krull, unidentified, Beverly Keiser Benton, Bill Emerick, Janet Root Potthast, Betty Potthast Emerick, Bob Benton, Loren Douglas, Margretha Banks Douglas, Mike Douglas, unidentified, Tom Douglas, Arnold Potthast, Ella Mae Johnson Douglas, and Aileen Van Voorhis Krull.

Another family to leave Minnesota for Rio
Linda was the John and Mary Matushak
family. They arrived in May 1919 and
settled on Rio Linda Boulevard, where
they had a chicken ranch and an orchard
of peaches and olives. The couple had
two children, Louis Raymond and Helen
M. John was a charter member of the
Rio Linda Poultry Producers Association.
(Courtesy California State Library.)

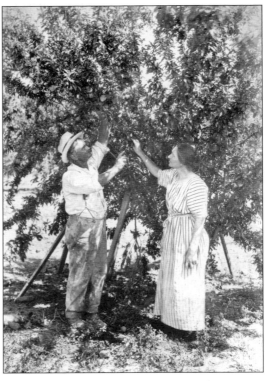

Alyce Johnson was a native of Norway who
immigrated to Minnesota, then came to Rio
Linda in 1928. Her husband, Carl E. Johnson,
was born in Minnesota to Swedish parents.
Carl first partnered with Peter Stenberg to
open a store, Stenberg and Johnson, then
later owned and operated Johnson Electric.
Alyce and Carl had one daughter, Irene.
(Courtesy Irene Johnson Fallon.)

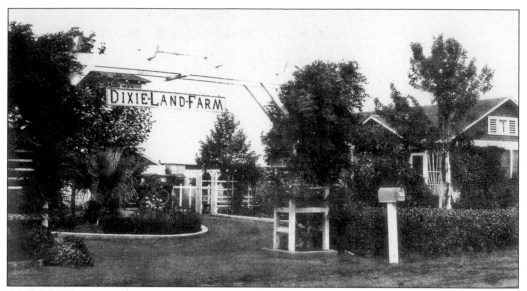

Dixieland Farm was the home of Franz Dicks, who came to the area in 1921. Franz was a distinguished representative of the German school of music and was a popular director and music teacher in Sacramento. (Courtesy SAMCC.)

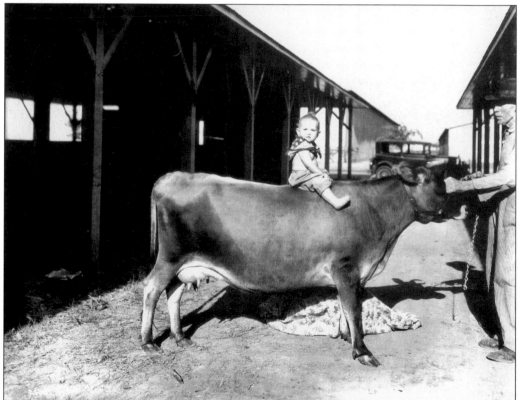

Otto Dicks, son of Franz and Antoinette Dicks, sits atop one of the family's cows on the Dixieland Farm. Otto learned to play popular music on the piano from John Wilson and for many years played at the Hong Kong Lum Chinese Restaurant in Sacramento. (Courtesy SAMCC.)

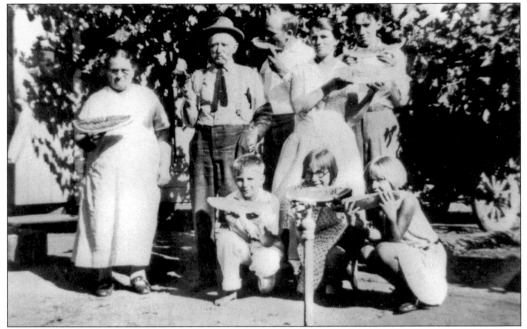

Jakobina Posehn and her husband, Johann Braun, with their son John and his wife, Lydia; son Bill; grandchildren Alvin and Laura; and an unidentified girl are enjoying watermelon, which was probably grown on their ranch. They came from Davin, Saskatchewan, Canada, to Rio Linda in 1923. (Courtesy Margaret Posehn.)

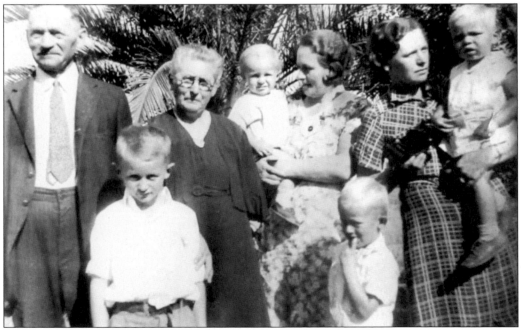

Henry Posehn followed his sister Jakobina's family to Rio Linda and became a poultry rancher. This photograph shows Henry with his wife, Christine; daughter Emma Klein, holding her nephew Franklin Dysart; and daughter Rose Krueger, holding her son Bill. Henry's grandsons, Art and Rich Klein, are in front. (Courtesy Margaret Posehn.)

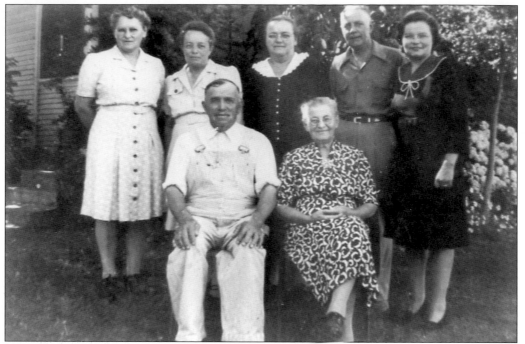

Johann and Elizabeth Posehn also followed his sister Jakobina to Rio Linda. Pictured here, from left to right, are (first row) John and Elizabeth; (second row) Ida Hodel Posehn, Emma Hodel, Emilie Wahl, and Elmer and Esther Skoglund. (Courtesy Margaret Posehn.)

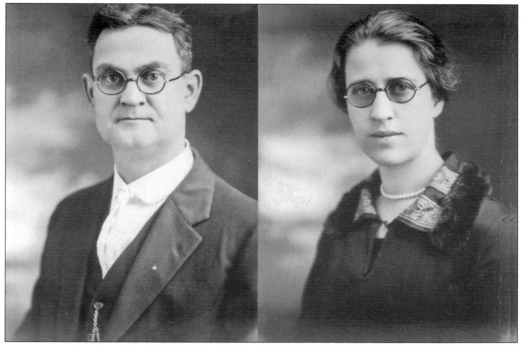

Wanda Faulds taught deaf students in Wisconsin, where she met Virgil Taylor. In 1918, they were married in Minnesota. They came to Rio Linda in 1925 and soon started a poultry ranch. Wanda lived to be 100 years old. (Courtesy Margaret Posehn.)

Another couple from Wisconsin, Walter and Florence Melin, came to Rio Linda in 1923. They were dairy farmers in Wisconsin, but took up the poultry business when they moved to this area. They had four children: Vernier, Olive, Robert, and Jane. (Courtesy Marge Krans.)

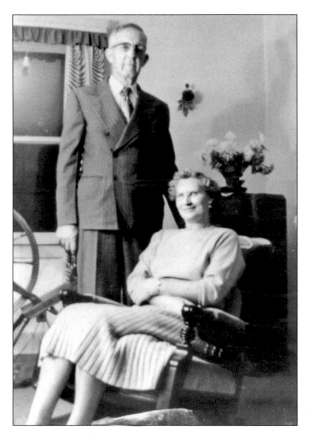

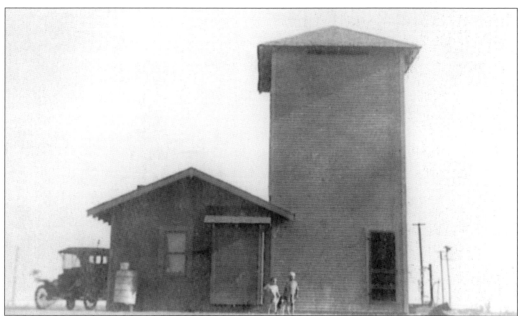

The Melin home and tank house was located in an area called Vineland, a part of the Rio Linda subdivision. (Courtesy Marge Krans.)

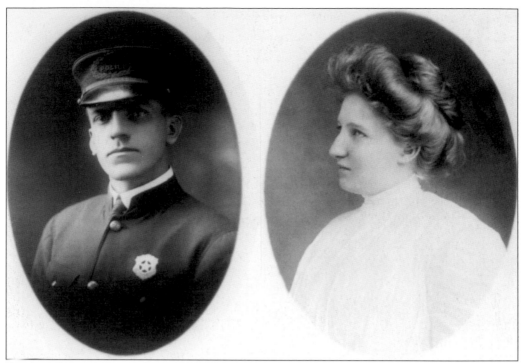

Frank and Gertrude Weckman, both born in Minnesota, came to Rio Linda about 1920 from South Dakota. They had four children: twins Eugene and Clarence, Dorothy, and Kenneth. Frank raised cows, chickens, and pigs but also worked at the mill. (Courtesy Frank Weckman.)

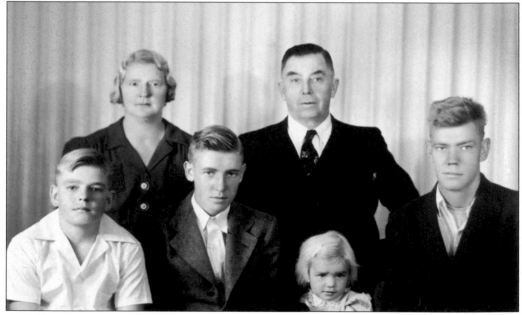

Gust Krans, a native of Germany, and Alma Peterson, of Swedish descent, were married in Minnesota and came to Rio Linda in 1925. They had a poultry ranch located on Thirty-second and I Streets. Pictured, from left to right, are (first row) Vern, Robert, Betty, and James (Jim); (second row) Alma and Gust. (Courtesy Marge Krans.)

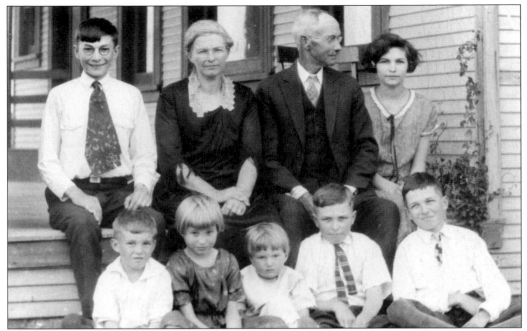

Members of the Wilson family, pictured here, from left to right, are (first row) George F. Jr., Carol, Marge, Marshall, and Stanley; (second row) John, Myrtle and George F. Sr. (the parents), and Blanche. George was a poultry rancher, and his wife, Myrtle, was postmistress at the Rio Linda Post Office. (Courtesy Janet Nunn Feil.)

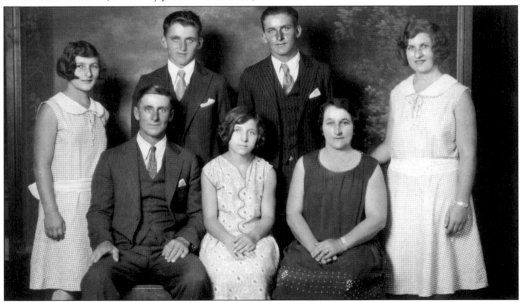

The Hayer family, pictured here in September 1930, from left to right, are (first row) Oley Earl, Hazel Addie, and Fanny Ann Hayer; (second row) Daisy Marie, Roiden (Roy) Earl, Elmer Arnold, and Irene Hayer. They came to this area in 1920 and built a house and poultry ranch on Thirty-second and E Streets. Roy later assisted with the Chik N Q (the successor of the Chick and Egg Festival), built Rio Linda Airport, established Hayer Park, and created the Bell Aqua Lakes. (Courtesy Marlene Hayer Bastian.)

The Sisler family lived on El Reno Avenue in Elverta and ran a turkey ranch. In 1926, Bessie and Ray Sisler came to Elverta from Minnesota, and had eight children. Ray also worked for Pacific Fruit Express (PFE) as a car inspector. (Courtesy Virginia Sisler Chapman.)

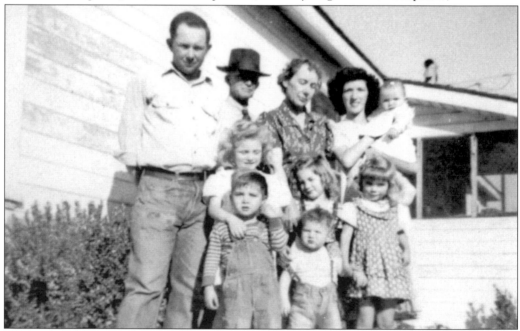

Members of the Gray family, pictured here, from left to right, are (first row) Buddy and Bobby; (second row) Gloria, Donna, and Shirley; (third row) Donly Jr., Donly Sr., and his wife, Mary; and Geneive (daughter-in-law), holding her daughter Kathy. The Grays purchased land in the Riego area to grow rice but later established a nursery. (Courtesy Donly Gray.)

Around 1880, George Mott Sr. purchased land on the west side of Dry Creek as an investment. The family later moved to the ranch in 1919 and owned a cherry orchard on Cherry Island. The Mott family, pictured here in 1939, from left to right, are (first row) James, Margaret and Denson (Denny); (second row) John, Bessie, Kittie Lawler (Bessie's mother), Emaline Bates, Laura, and George (holding baby Thomas). (Courtesy Denson Mott.)

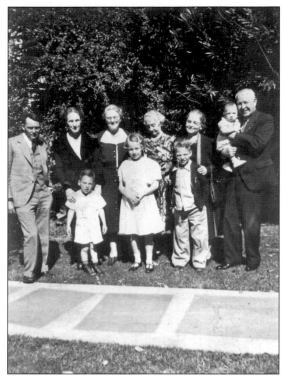

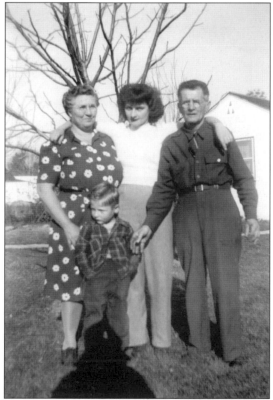

In 1937, Beata and Andrew Eissinger came to Rio Linda from the Dakotas with their five children: Irene, Arnold, John, Art, and Catherine. Andrew worked as a carpenter, and Beata worked for Gross's Variety. Their son Arthur became a municipal court judge in Sacramento. In this photograph, the Eissingers pose with their daughter Irene and grandson Steven. (Courtesy Don Ramey.)

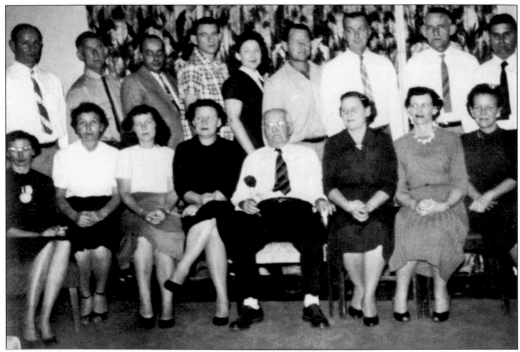

For a decade, beginning in 1943, the Geiger family owned and lived on property between the two forks of Dry Creek, now called the Dry Creek Ranch. The Geiger family, pictured here, from left to right, are (first row) JoAnn, Joyce, Betty Hanson, Ruth Musgrave, George, Margaret Kelley, Anne, and Lois Rodrigues; (second row) Earl, Clarence, Dave Hanson, Don, Jeanette, Lester, Ray Kelley, Elmer, and Joe Rodrigues. (Courtesy Carol Geiger Fanchar.)

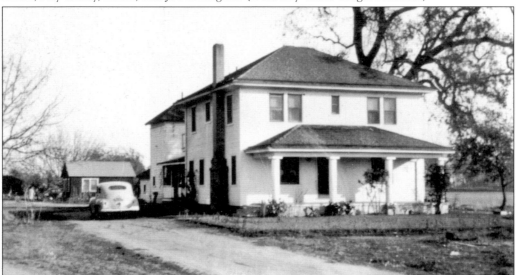

In 1947, the Geiger home included a tank house and other buildings behind the house. The Geigers ran a dairy for several years, then sold the property to the Church of Jesus Christ of Latter-day Saints in 1953. The LDS church later sold the ranch to Dan Paige and Charles Morris. In 1995, the ranch was sold to Sacramento County. It is now leased by the Rio Linda/ Elverta Historical Society. (Courtesy Carol Geiger Fanchar.)

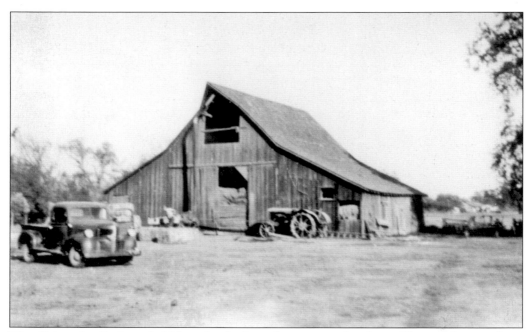

The Geiger family barn held hay for feeding the cows at the dairy. The ranch was about 180 acres. Over the years, the ranch was used for dairy land, an orchard, and growing crops. (Courtesy Carol Geiger Fanchar.)

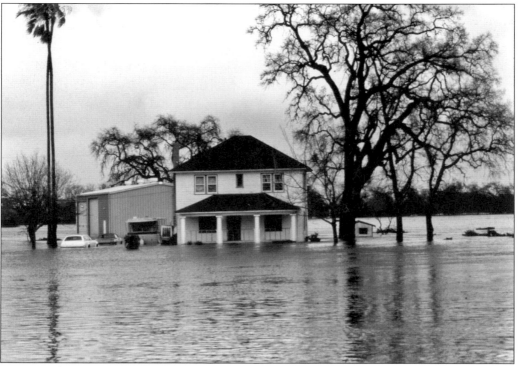

Because of its geographical location between the forks of Dry Creek, the ranch is subject to flooding, evidenced here in a 1980s flood. The ranch house is high enough that water, so far, has not covered the floor, but it comes very close to it.

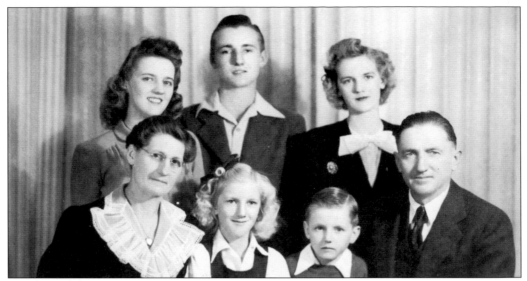

In 1930, Henry and Emily Meyer came to Elverta from Michigan. Henry first worked for the Chaffins bailing hay. Later he landed a job as custodian for Grant Union High School. This family photograph, taken about 1941, from left to right, includes (first row) Emily (Millie), Leone, Erwin (Butch), and Henry Meyer; (second row) Viola (Vi), Clarence, and Erna. (Courtesy Leone Thorne.)

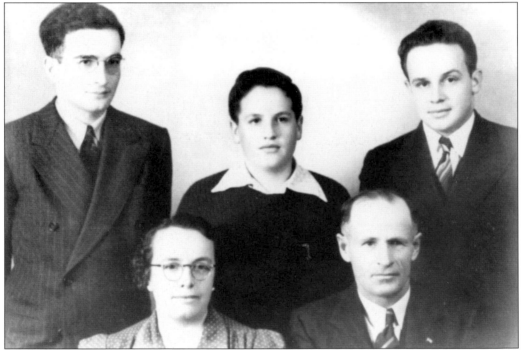

John and Emma Hodel and their three sons left Saskatchewan for Michigan, where John worked in a car factory. When they came to Rio Linda in the late 1930s, John worked as a contractor, building many of the fine houses in this area. He also helped build Calvary Lutheran Church. Pictured here about 1940, from left to right, are (first row) Emma and John Hodel; (second row) Robert, Ted, and Gordon Hodel. (Courtesy Margaret Posehn.)

Four

THE POULTRY BUSINESS

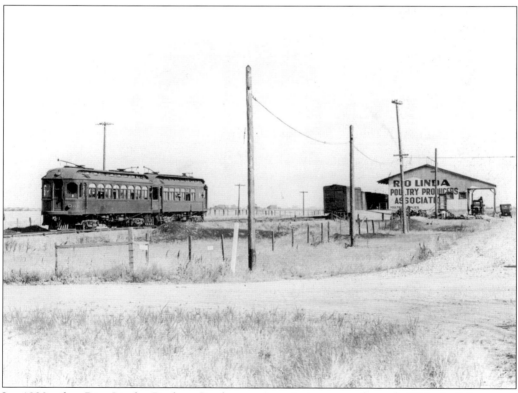

In 1920, the Rio Linda Poultry Producers Association was formed. This building was constructed to hold feed and grain for purchase by local ranchers. The seven charter members of the association were Michael Blocher, Sam Chapman, Gustaf Donsing, Bonepart Harris, John Matushak, Dan Nash, and John Nelson. A Sacramento Northern train and the Rio Linda Poultry Producers building are pictured here. (Courtesy Leone Thorne.)

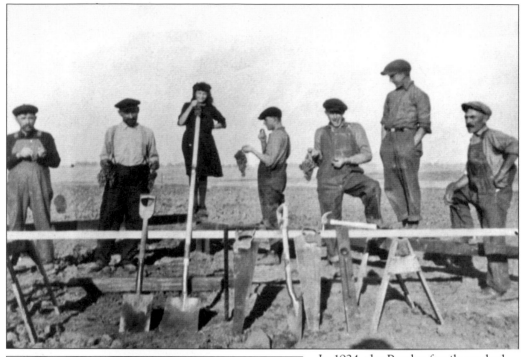

In 1924, the Posehn family worked together to build Robert's first chicken coop on Q Street in Rio Linda. Pictured here, from left to right, are John Posehn, Henry Posehn, Esther Posehn, Peter Posehn, Fred Klein, Bill Posehn, and Henry Braun. (Courtesy Margaret Posehn.)

John Posehn, pictured here in his work clothes, raised chickens and grew wheat on his ranch in Rio Linda. (Courtesy Margaret Posehn.)

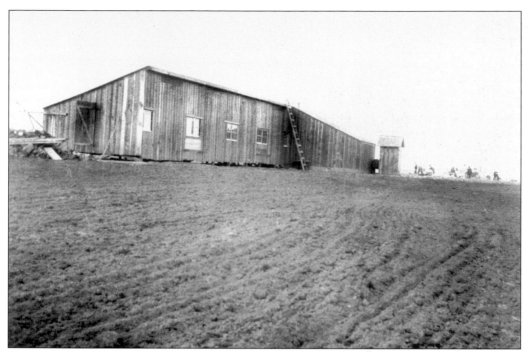

Here is Robert Posehn's first chicken coop, complete with an outhouse. Many early families lived in tank houses or portions of a chicken coop until a house could be built. (Courtesy Herb Posehn.)

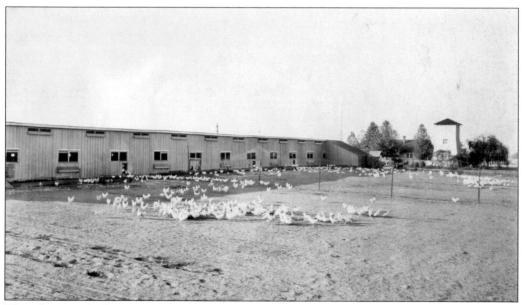

This photograph shows Robert Posehn's chicken ranch in 1928, with a house and tank house. The tank house was used to store water but often was also used for storage space. (Courtesy Herb Posehn.)

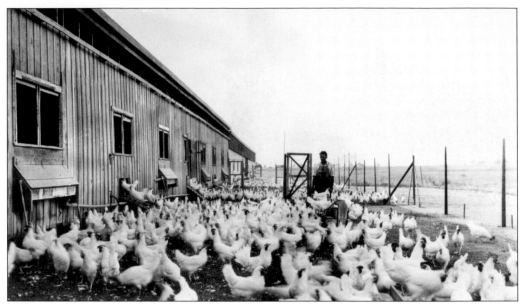

A rancher stands among his chickens as they spend time outside of the coop. This style was typical of many chicken coops in the area. Most included fenced areas so the chickens could be outside during the day. (Courtesy Margaret Posehn.)

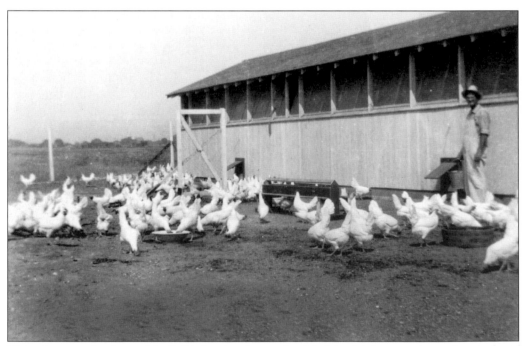

This photograph shows Virgil Taylor in the yard with his chickens and another style of coop construction. Chickens could usually feed inside as well as outside the coop, but nests for egg laying were always inside. (Courtesy Margaret Posehn.)

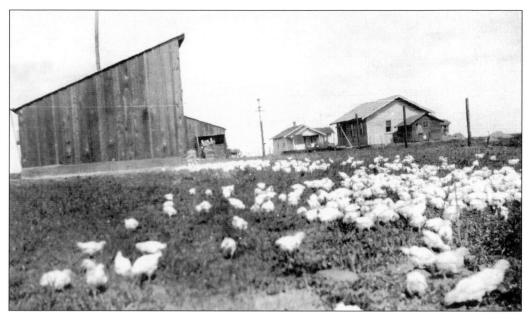

Archie and Jessie Houghtaling lived on this chicken ranch where they let their young chicks run outside. They came to Rio Linda in November 1921 from Minnesota, bringing their two daughters, Alice and Margaret. (Courtesy Carol Schulte Sherrets.)

Virgil Taylor had more than one style of chicken coop, as pictured in this photograph. There was always a lot of work to be done on a chicken ranch—feeding, gathering eggs, cleaning out manure, and vaccinating when needed. (Courtesy Margaret Posehn.)

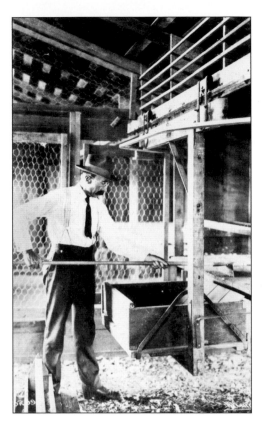

The services of Peter R. Lyding were secured by the Sacramento Suburban Fruit Lands Company to provide free assistance to those who purchased land from the company. He offered guidance on how to build chicken coops and how to look after the chickens. Lyding is pictured here with his box invention, created to ease the workload. (Courtesy California State Library.)

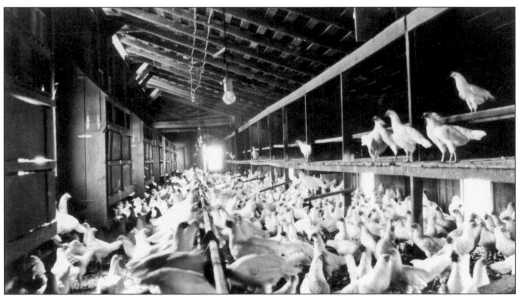

The inside of a Lyding chicken coop shows the nest boxes on the left, the feeding troughs in the center, and the roosts used at nighttime to the right. (Courtesy California State Library.)

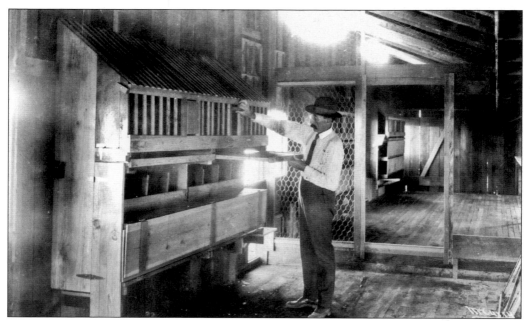

Peter Lyding was proud of his nest boxes, showing them off in this photograph. He was always looking for ways to improve the poultry industry. (Courtesy California State Library.)

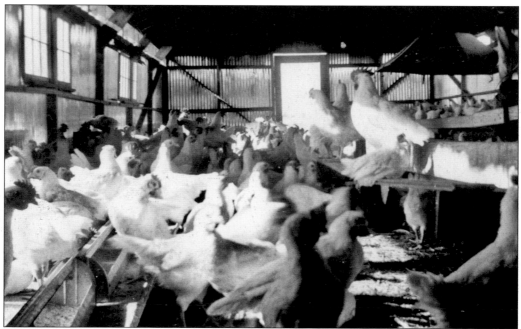

Most of the chicken coops in the area were built with all wood construction, but a few, like this one on the Jim Krans ranch, were covered in aluminum. (Courtesy Marge Krans.)

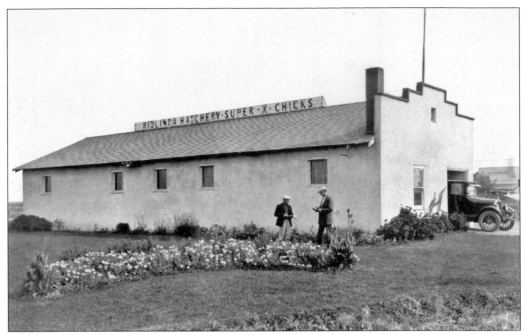

Built in 1922 by M. J. Kramer of Minnesota, the Rio Linda Hatchery provided baby chicks to many of the local ranchers. When this hatchery closed, the building was used as a pool hall by Pat Griggs. It later became Bill's Soda Fountain. (Courtesy California State Library.)

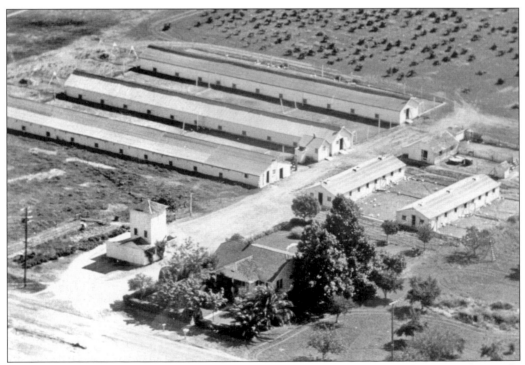

This was the Sylvester Weisgerber chicken ranch, located on Twenty-eighth Street. The ranch, purchased from Fred Buehler, had an orchard in the back. (Courtesy Marge Krans.)

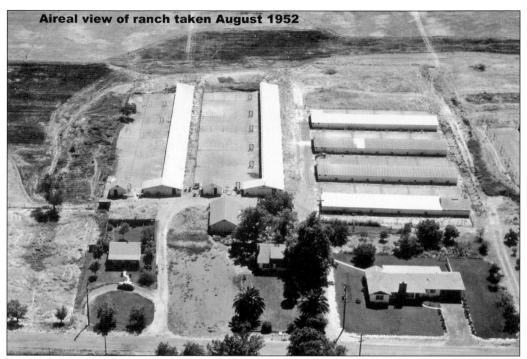

Aireal view of ranch taken August 1952

In 1952, Robert Posehn's chicken ranch had grown considerably from the first coop built in 1924. When the Posehns went out of the chicken business, the coops were converted for mini-storage units. (Courtesy Herb Posehn.)

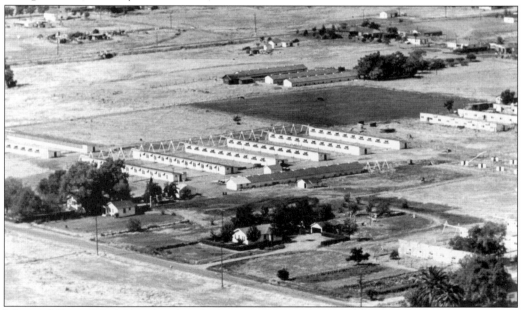

John and Emma Hodel lived at this chicken ranch on Twenty-eighth Street in Rio Linda. There were many chicken ranches in the area, and Rio Linda was often referred to as the Egg Capitol of the country. The house in the middle of this photograph belonged to August and Rose Krueger, and the chicken coops on the bottom right belonged to Merrill and Thelma Clark. (Courtesy Margaret Posehn.)

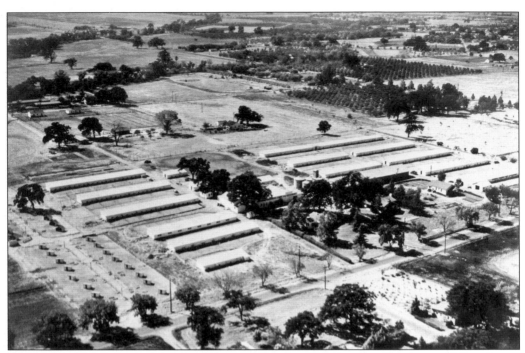

The Donsing Hatchery and Breeding Farm covered many acres on Q Street in Rio Linda. White leghorn chickens were the primary product of the hatchery, and baby chicks were supplied to many local ranchers as well as shipped all over the country. (Courtesy Wilbur Donsing.)

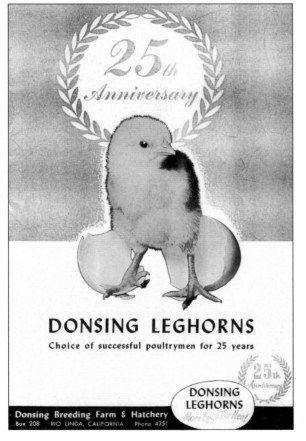

In 1952, this cute, little chick graced the cover of the 25th anniversary booklet printed for Donsing's Breeding Farm and Hatchery. (Courtesy Wilbur Donsing.)

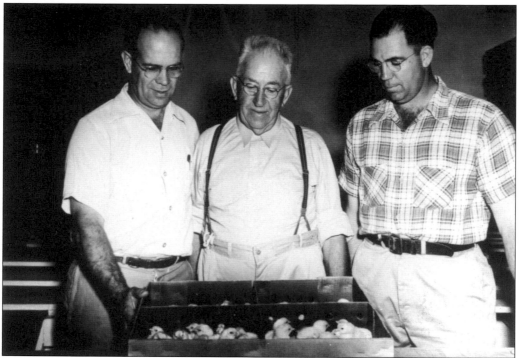

Fred, Gustav, and Wilbur Donsing inspect a crate of baby chicks ready for shipping. (Courtesy Wilbur Donsing.)

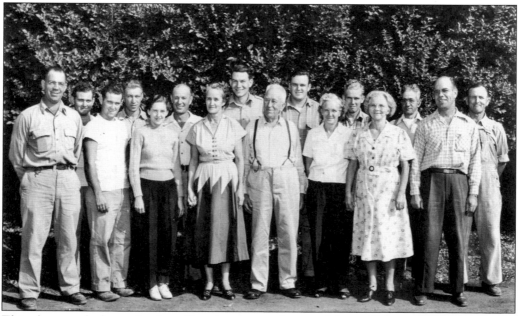

This photograph shows the three Donsing men and some of the staff that worked for Donsing Breeding Farm and Hatchery. Pictured, from left to right, are (first row) Wilbur Donsing, Wes Davey, Rose Mueller, Grace Thorne, Gustav Donsing, Martha Weisenburger, Anna Buehler, and Fred Donsing; (second row) Wayne Davey, Bill Welliver, Harold Mueller, Henry Jeppesen, Dwight Penick, Dale Weisenburger, Joe Santos, and Tom Buehler. (Courtesy Wilbur Donsing.)

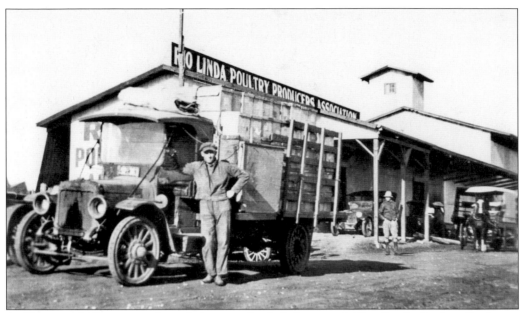

A Harris and Devine truck and driver is loaded down with Rio Linda Poultry Producers Association members' eggs for market. At the time this photograph was taken, there was at least one rancher making deliveries by horse and wagon. (Courtesy Ruby Harris.)

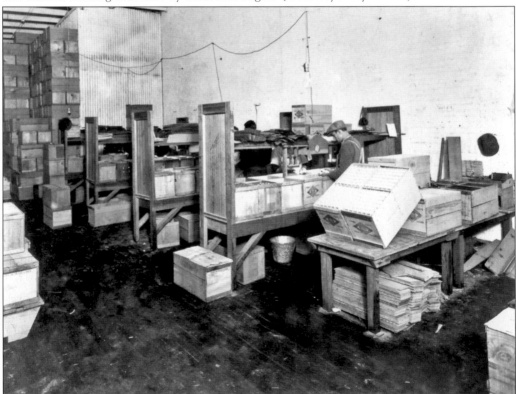

Inside the Rio Linda Poultry Producers Association building, workers cleaned and inspected the eggs before they were crated and shipped out. (Courtesy California State Library.)

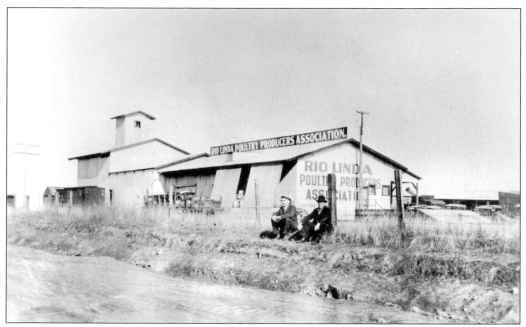

As the poultry business flourished in the area, so did the Rio Linda Poultry Producers Association, and the facility was expanded to meet the growing needs of the ranchers. (Courtesy Marge Krans.)

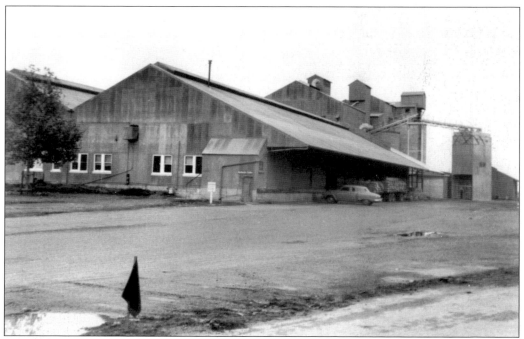

By 1951, the Rio Linda Poultry Producers Association building had undergone major expansion, including grain silos. (Courtesy Margaret Posehn.)

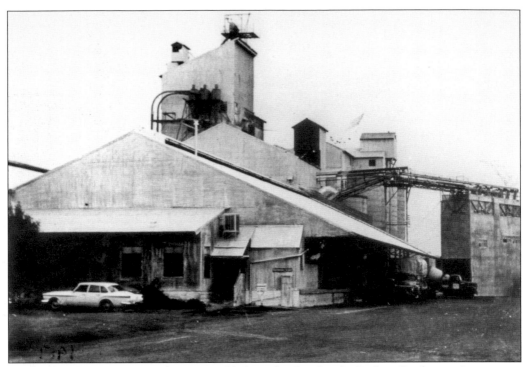

By the 1960s, more grain silos were added to the Rio Linda Poultry Producers Association building. However, the poultry industry began to decline during this period, and within 10 years, there were very few chicken ranches left. (Courtesy Margaret Posehn.)

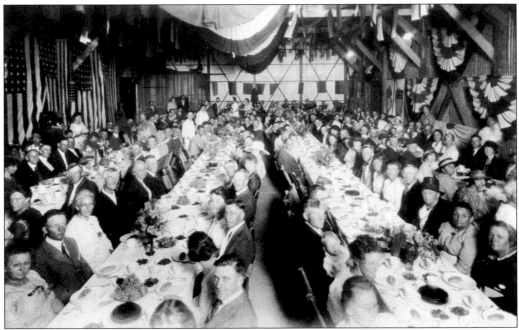

Membership in the Rio Linda Poultry Producers Association grew quite rapidly. This photograph shows members at a dinner hosted by the organization during its early years. (Courtesy Wilbur Donsing.)

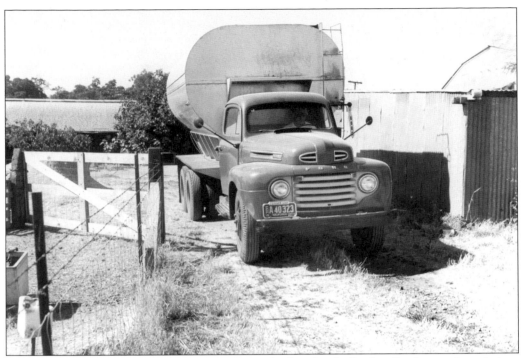

Modernization brought feed delivery trucks to the Rio Linda Poultry Producers Association. This one is making a delivery to a local rancher in 1952. (Courtesy Margaret Kaffka Garrehy.)

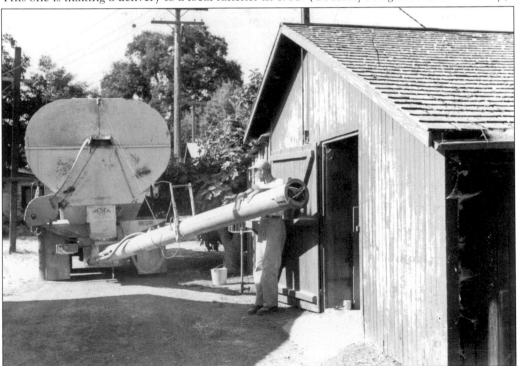

A conveyor is guided toward the feed bin inside the door of the chicken coop where the feed was dumped. It took about 45 minutes to fill the feeder bins. (Courtesy Margaret Kaffka Garrehy.)

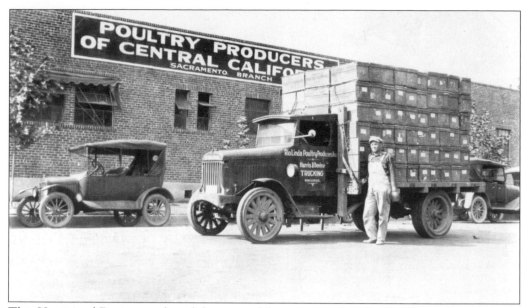

This Harris and Devine truck and driver are delivering eggs from Rio Linda Poultry Producers Association members to the Poultry Producers of Central California, Sacramento Branch. (Courtesy Ruby Harris.)

Irvine Beattie works on the outside of his Elverta Hatchery in this photograph. The hatchery supplied young turkeys for many of the local residents, including the Sislers in Elverta and the Fiddyments in Antelope. (Courtesy SAMCC.)

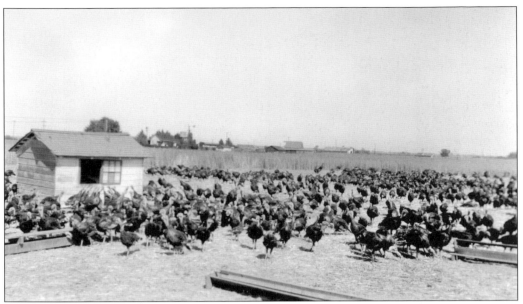

These turkeys, purchased from the Elverta Hatchery, were raised on the Ray and Bess Sisler ranch in Elverta. (Courtesy Virginia Sisler Chapman.)

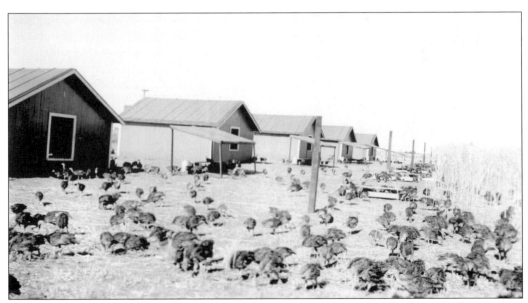

Turkey sheds were much smaller than chicken coops and were used primarily for roosting at night. The sheds and turkeys in this photograph are on the Ray Sisler ranch in Elverta. (Courtesy Virginia Sisler Chapman.)

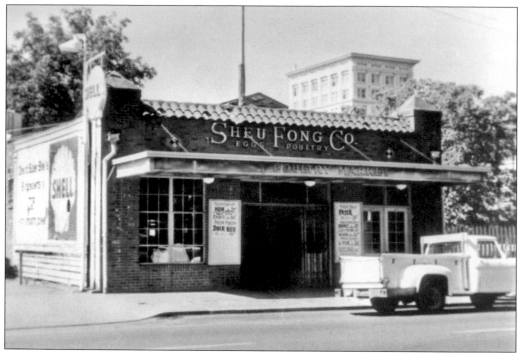

Sheu Fong Company, located at 420 I Street in Sacramento, was owned and operated by Bert Sui Fong, a native of China, who immigrated in 1910. Many of the local poultry ranchers sold their non-laying hens to Bert so they could be butchered and sold in his store. (Courtesy SAMCC.)

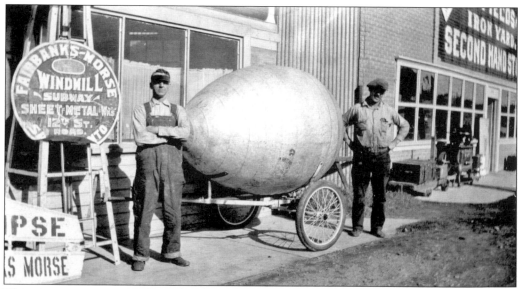

This giant egg was created at a local machine shop for Robert Posehn, who then set it up by the driveway of his chicken ranch. It was a good advertisement for selling eggs. (Courtesy Margaret Posehn.)

Five

LOCAL BUSINESSES

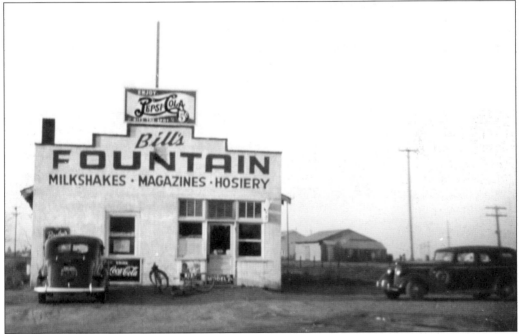

Of all the buildings in Rio Linda and Elverta, this one has probably undergone the most transformations. It started out as the Rio Linda Hatchery, became a pool hall in the 1930s, then Bill's Soda Fountain in 1939 when Bill Gross purchased it. After Bill retired, it became McMillan's Hardware, and in 2004, it was modernized and is now the home of RCI Plumbing and General Contractors, owned by the Risse family. When Bill Gross opened his soda fountain, there was still a pool hall in the back of the building. (Courtesy Joan Gross Paul and Alice Gross.)

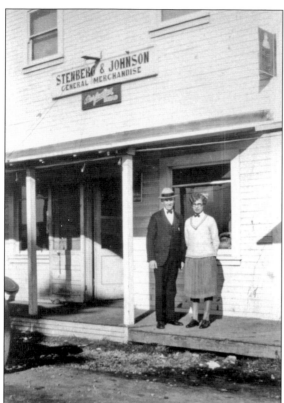

Stenberg and Johnson was a general merchandise store in Rio Linda, owned and operated by Peter Stenberg and Carl Johnson. When Stenberg moved the store next door, this one became the Johnson Electric store. (Courtesy Irene Johnson Fallon.)

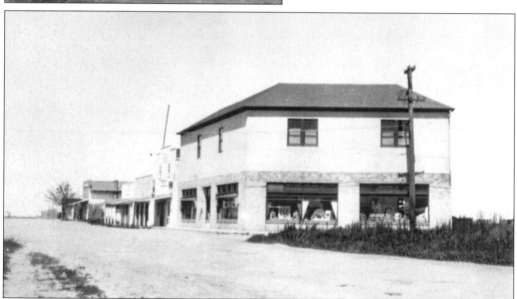

This view shows the businesses on the east side of Front Street, heading north toward the Rio Linda Poultry Producers Association building. The two-story building in front, constructed by P. M. Norbryhn in 1927, was occupied by Stenberg and Johnson, and the upper floor was used by various fraternal and civic organizations, including the Rebekahs. The second store was later used by Johnson Electric, and McVey's Barber Shop was next. Norbryhn's Lumber store was on the end. (Courtesy Irene Johnson Fallon.)

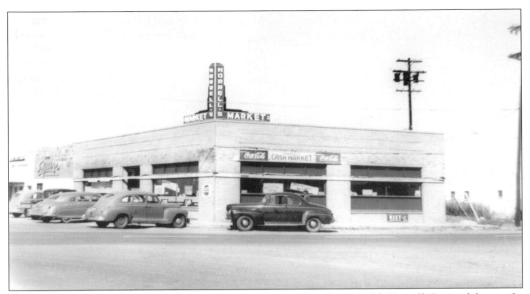

Horrell's Market in the early days was only one story high. Harold Horrell Sr. and his wife, Kathryn Thompson, ran the store with the assistance of their five children. (Courtesy Eloise Wagner collection.)

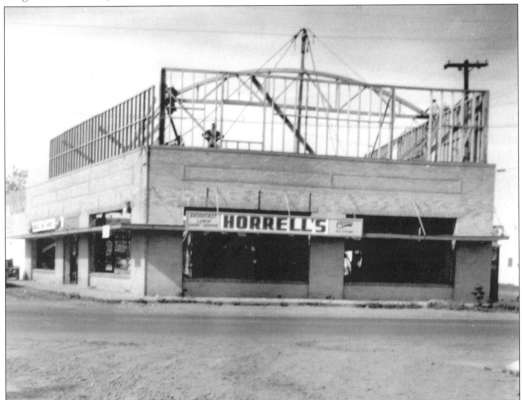

After a terrible fire in Horrell's Market, the structure was rebuilt, this time with a second story. The Oddfellows and Rebekahs met in the second floor rooms. (Courtesy Eloise Wagner collection.)

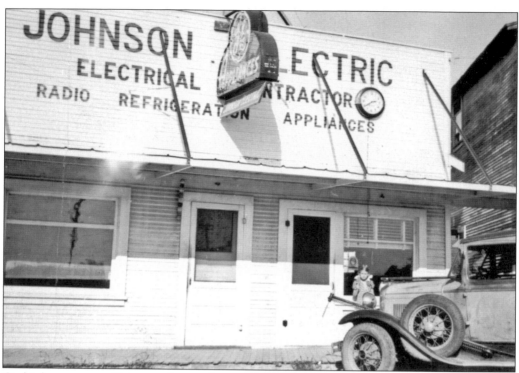

Carl Johnson started his own electrical contractor business, Johnson Electric, and began selling electrical appliances in Rio Linda. His wife, Alyce, worked in the store, selling appliances to local residents. (Courtesy Irene Johnson Fallon.)

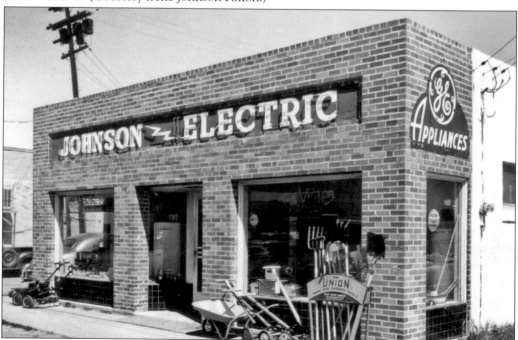

Several years later, Johnson Electric moved around the corner to this brick building. Although it was an appliance store, gardening tools were also offered. (Courtesy Irene Johnson Fallon.)

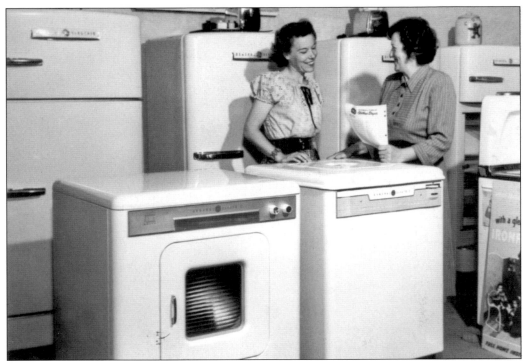

Alyce Johnson, right, now a widow, discusses the latest appliances with a customer in her store, Johnson Electric. Many local residents like to haggle over prices with Alyce for a better deal. (Courtesy Irene Johnson Fallon.)

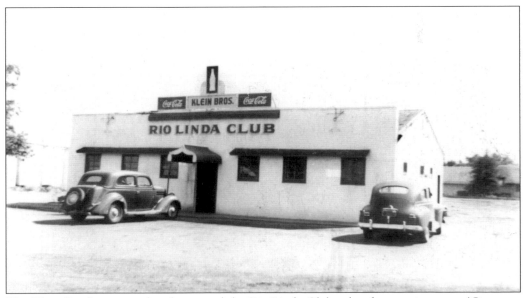

The Klein Brothers owned and operated the Rio Linda Club, a local tavern in town. (Courtesy Eloise Wagner collection.)

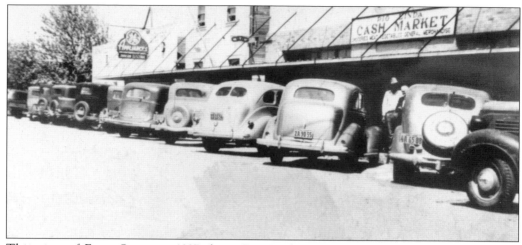

This view of Front Street in 1937 shows Rio Linda Cash Market (which became Horrell's Market) and Johnson Electric. Business was good, judging by the number of cars parked out front. (Courtesy Norma Horrell.)

Russ Grocery was located on the west side of the railroad tracks on Front Street, next to the Rio Linda fire station. The Russ family, Art and Violet, owned and operated the market for many years. Rio Linda resident Tom Dougla recalled that there wa a key for the freight shed that hung on the wall inside of Russ Market. When residents expected shipments on the train, they would borrow the key, check in the freight shed, and then return the key. (Courtesy Eloise Wagner collection.)

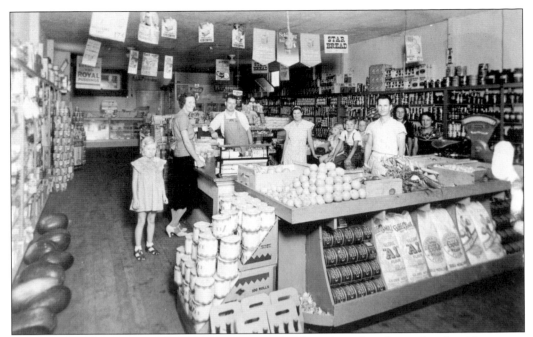

Art Russ owned and operated Russ Grocery in Rio Linda and employed many local residents over the years. Pictured here, from left to right, is unidentified, Hazel Palmer, Art Russ, Violet Russ, Janie and Jerry Russ, unidentified, Ray Keeling (the butcher), Katie Eissinger, and unidentified. (Courtesy Janice Yeargain.)

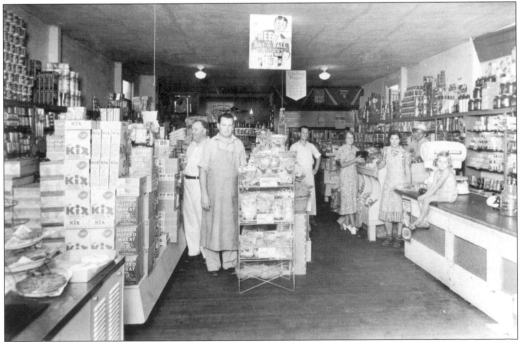

This photograph shows another view of Russ Grocery. Art Russ is the second from the left, Roy Keeling is the butcher, and Violet Russ is third from the right. Little Janice Russ is at the counter. (Courtesy Janice Yeargain.)

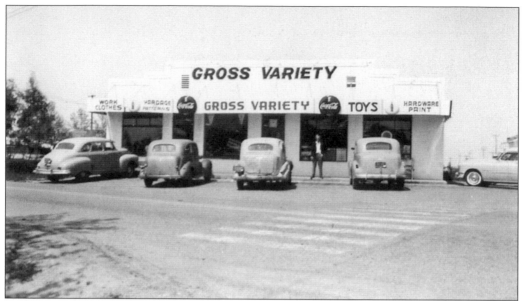

Bill's Soda Fountain and Pool Hall later became Gross Variety and expanded in size from the original hatchery building. The store carried hardware, paint, toys, work clothes and yardage, and a variety of goods for home and personal use. It was a popular place for young and old alike, and being across the street from the grammar school, it was a favorite place to stop on the way home from school. Beata Eissinger worked at Gross Variety for many years. (Courtesy Joan Gross Paul and Alice Gross.)

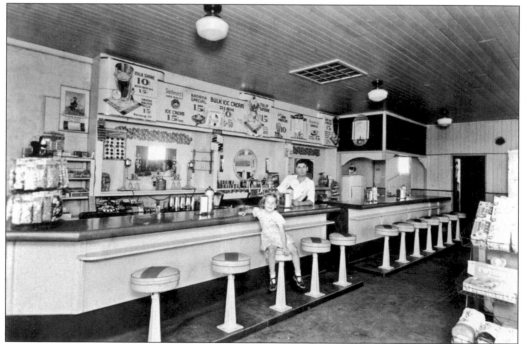

The soda fountain in Gross Variety was the place to go for ice cream treats, including sodas, sundaes, and milk shakes. Joan Gross sits on a stool at the counter, and her father, Bill Gross, is leaning on the counter. (Courtesy Joan Gross Paul and Alice Gross.)

Gyda Davey first operated a small restaurant in the Harris and Devine station, then later moved into this building behind the station. It was called Davey's Lunch-Liberty Ice Cream, but it served breakfast, lunch, and dinner. (Courtesy Wesley Davey.)

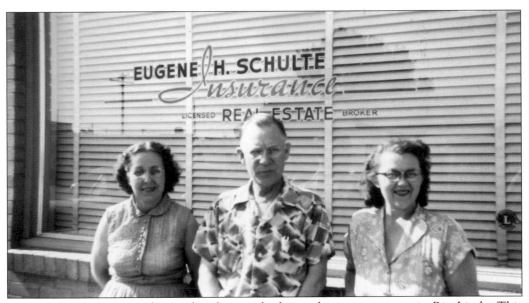

Eugene H. Schulte was a licensed real estate broker and insurance agent in Rio Linda. This photograph, taken in front of the office, shows Eugene (middle), his wife, Alice (right), and Beatrice Eia, who worked for him. (Courtesy Carol Schulte Sherrets.)

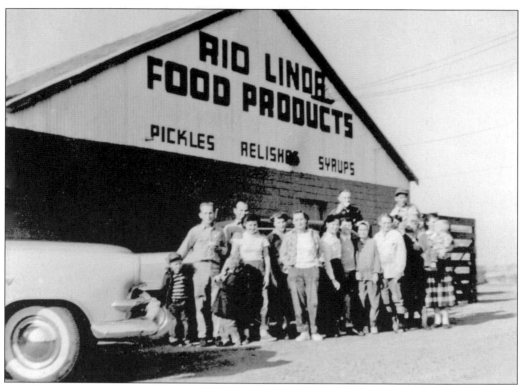

Rio Linda Food Products was better known in the community as the Pickle Factory. The company was started by Irving Lein and his brother Curtis in 1948. They provided pickles, relishes, and syrups. (Courtesy Beatrice Lein.)

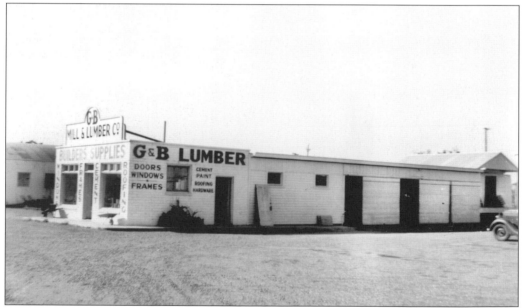

G and B Lumber, a partnership between Conrad (Connie) Gerolamy and Dick Bolden, provided milled lumber for customers. Connie's wife, Noma Chapman, was the company's bookkeeper. (Courtesy Noma Chapman Gerolamy.)

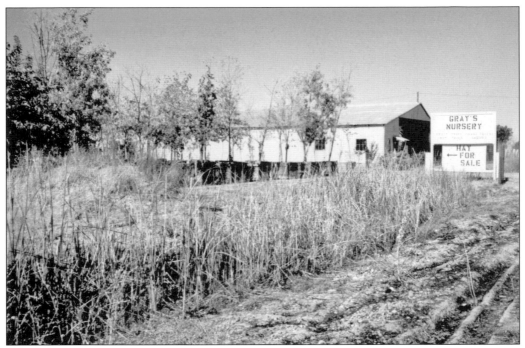

Residents who needed trees could find them at Gray's Nursery in Riego. The nursery was started in 1929 by Donly Gray Sr., who was known for growing the Dawn Redwood, a tree from Tibet, and donating them to various organizations. (Courtesy Marge Krans.)

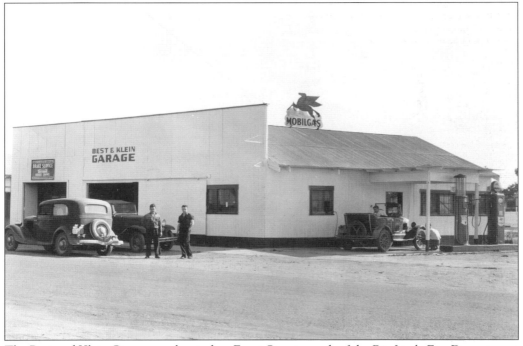

The Best and Klein Garage was located on Front Street, north of the Rio Linda Fire Department station. This photograph shows Clarence "Babe" Best (left) and Johnny Klein standing out front. Babe Best later became the fire chief for Rio Linda. (Courtesy Tom Best.)

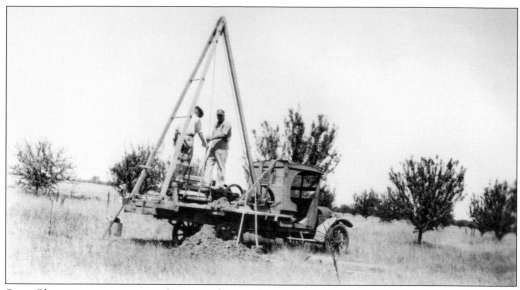

Sam Chapman was a man of many talents—he even drilled a number of water wells in the community. This photograph shows Sam, right, and another man working on his drilling rig. (Courtesy Sam and Nina Chapman collection.)

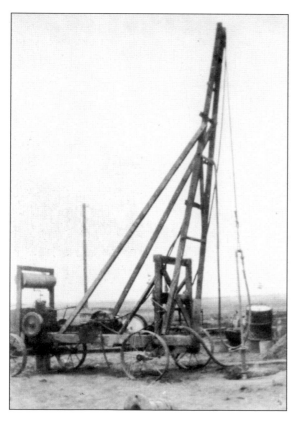

In Elverta, it was Frank McGrew who designed his own drilling rig and began drilling water wells. At that time, the water table level was 20 to 25 feet deep. (Courtesy Jim McGrew.)

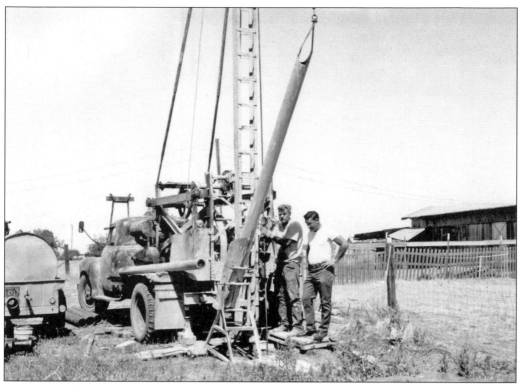

As the population grew in both communities, so did the need for water. Jim Krans learned the trade first from Sam Chapman and then Herman Anthis in the late 1950s. Jim drilled an incredible number of wells in the area and also provided service for water pumps. (Courtesy Marge Krans.)

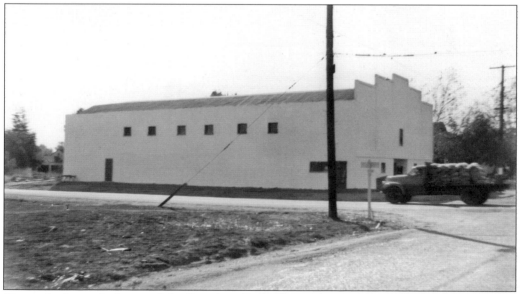

Currently this is the home of the Rite Auto Body Shop, a business started by Carl Rodoni and now operated by his son-in-law Brent Bowler. At one time, the building was a theatre, with equipment donated from Beale Air Force Base. (Courtesy Eloise Wagner collection.)

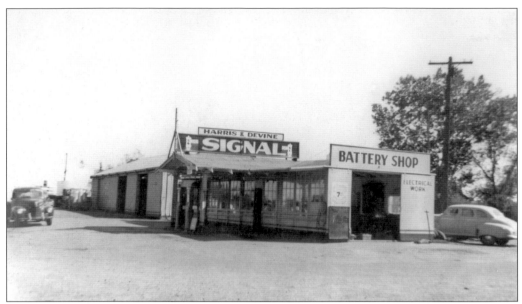

The Harris and Devine Signal Station on M Street in Rio Linda was headquarters for the business and had a large shop building on the east side of the property. The company had numerous trucks and hauled eggs, poultry feed, grain, and rice in addition to the service of this station. They also provided school buses for many years. (Courtesy Ruby Harris.)

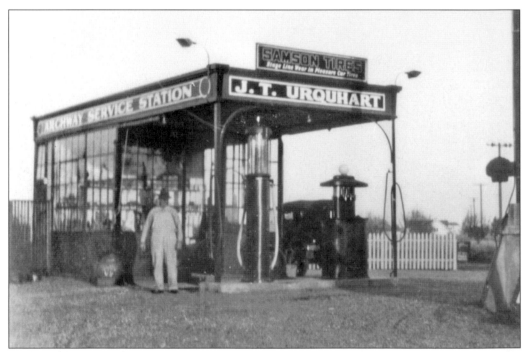

J. T. Urquhart owned and operated the Archway Service Station, located on the corner of Rio Linda Boulevard and M Street. It was so named because of the arch from Marysville erected over that intersection. (Courtesy Louise Urquhart Bullard.)

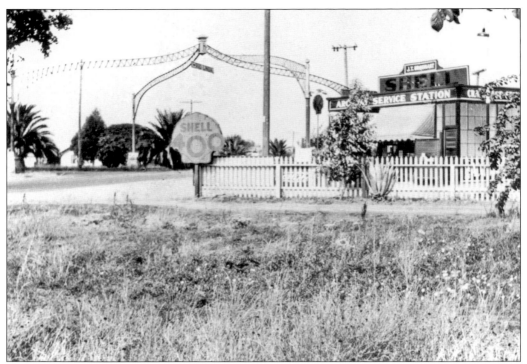

This view of the Archway Service Station shows the arch as well. The station is now offering Shell gasoline. (Courtesy Louise Urquhart Bullard.)

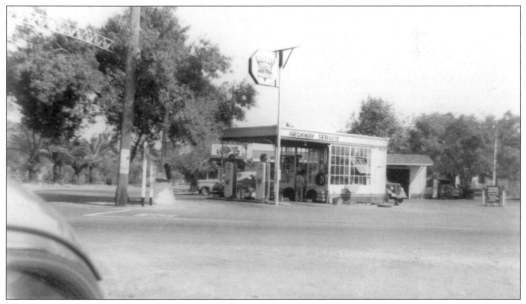

New gasoline pumps have been installed at the Archway Service Station. This station was still in business at the beginning of the 20th century but is now closed. (Courtesy Eloise Wagner collection.)

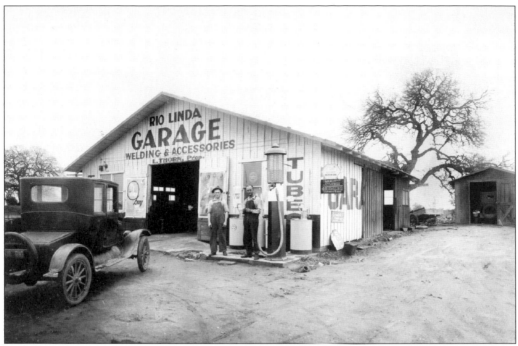

Les Thorn's garage was the first repair shop in Rio Linda. When the Rio Linda Fire Department purchased its first fire truck, Old Betsy, it was housed in this garage until the first station could be built. (Courtesy Sam and Nina Chapman collection.)

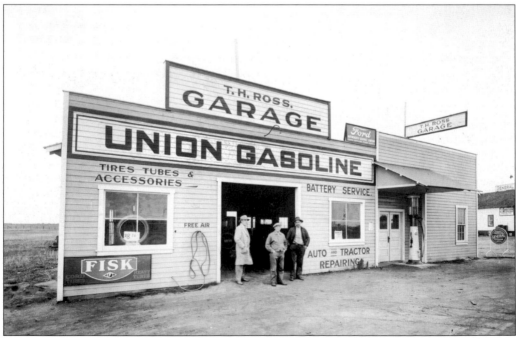

The T. H. Ross Garage in Elverta was located on Rio Linda Boulevard. It offered general repair and overhauling on all makes of cars and tractors. (Courtesy Dorothy Ross Morebeck.)

Six

EARLY SCHOOLS

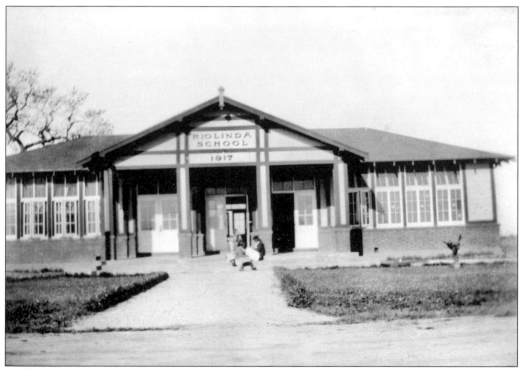

The first school building in Rio Linda was affectionately known as the Little Green Schoolhouse, and it served as a community hall and a place of worship for the Brethren church. This Rio Linda School building was constructed in 1917, but the work continued through 1923 as the facility grew. Noma Chapman Gerolamy, a student when this building opened for school, recalled the students marching across the street from the old schoolhouse to the new one, carrying their books and writing materials with them. (Courtesy John Lee Ernst.)

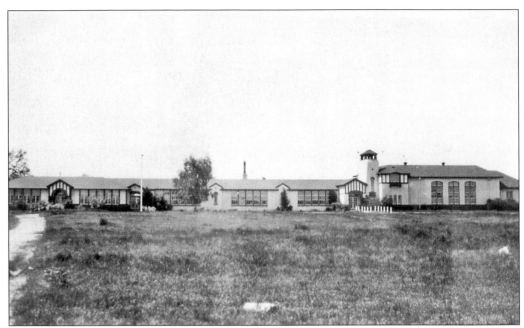

By 1923, the new Rio Linda Grammar School was completed. It now had a large auditorium and plenty of classrooms for the growing student population. (Courtesy Irene Johnson Fallon.)

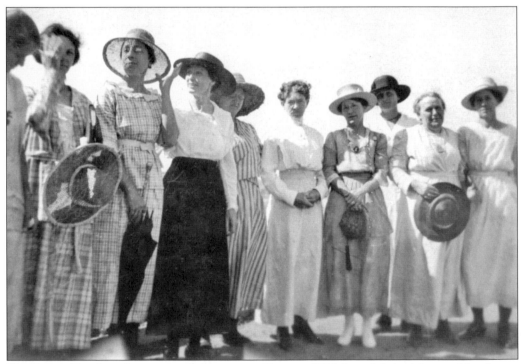

The Parent Teachers Association ladies pictured here in 1924, from left to right, are Mrs. Lester Thorn, Mrs. W. A. Weber, Mrs. Sam Chapman, Mrs. Dennis, Mrs. Root, Mrs. M. K. Johnson, Mrs. Martin Nelson, Mrs. Franz Dicks, Mrs. Phinney, and Mrs. Nash. (Courtesy Wilbur Donsing.)

The faculty of the Rio Linda Grammar School for 1920–1921 was Imogene Jackson; Albertine DuBoise, the principal; and Phoebe Jones. Many of Phoebe's students stayed in touch with her over the years, and she was invited to join them at the Early Timers' Luncheon in 1991. (Courtesy Wilbur Donsing.)

In 1921, the eighth grade graduating class from Rio Linda School included these students: Reed Herring, Louis Krumenacker, Maurice Reynolds, Lucille Weber, Findley King, Otis Whipple, Olga Chastes, Terrance Haines, Zelma Stretchell, Thelma Openchair, Lucinda Ernst, Bonnie Reynolds, Maurice Chapman, one of the Zine children, and Wilbur Donsing. (Courtesy Wilbur Donsing.)

In 1930, Warren Allison joined the Rio Linda School District as a teacher and later became its first superintendent, a position he held for 29 years. He was well respected in the community, and the school district later named a school for him. (Courtesy John Lee Ernst.)

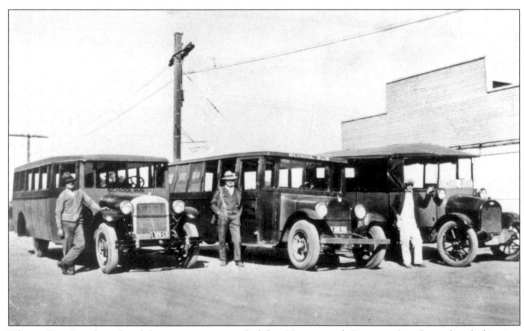

These Rio Linda school buses were provided by Harris and Devine for the school district. (Courtesy Ruby Harris.)

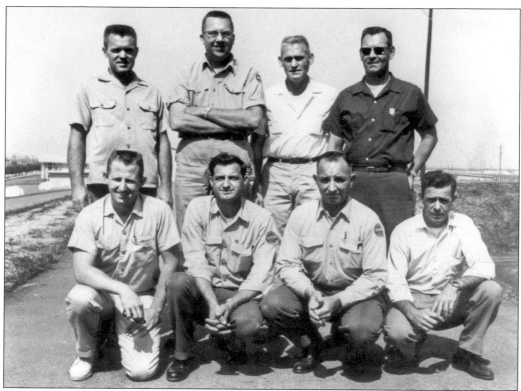

Rio Linda School District provided bus transportation for a large number of students, and these eight men were some of the bus drivers. Pictured, from left to right, are (first row) Gary Reynolds, Bill Grossman, Les Spears, and Eudell Ware; (second row) Waldo Berg, Gene Black, Ralph Moore, and Sylvester Draxton. (Courtesy Rio Linda Union School District.)

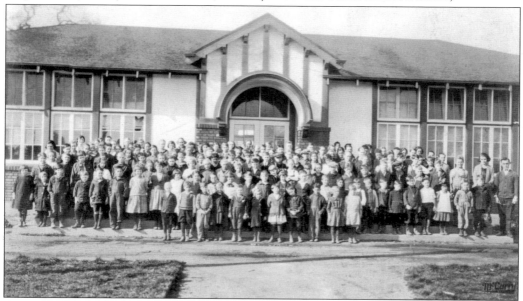

A new Rio Linda Elementary School building was completed in 1917, and this photograph shows all the students attending the school at that time. (Courtesy Rio Linda Union School District.)

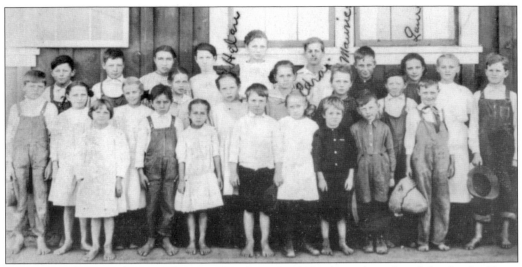

This class photograph was taken on October 25, 1915, along the side of the Little Green Schoolhouse. The teacher, not pictured, was Molly Vaughn, and the students were in grades one through eight. Pictured here, from left to right, are (first row) unidentified, Otis Whipple, Naomi Whipple, Owen Colbert, Edra Chapman, Franklin Colbert, and two unidentified; (second row) unidentified, unidentified, Olivett Giruad, unidentified, Helen Chapman, Mary Colbert, Morris Chapman and unidentified; (third row) unidentified, unidentified, May Whipple, Vera Terkelson, Esther Gentry, Rolland Hornbustal, unidentified, Lorrine Chapman, Ruth Gentry, and unidentified. (Courtesy Noma Chapman Gerolamy.)

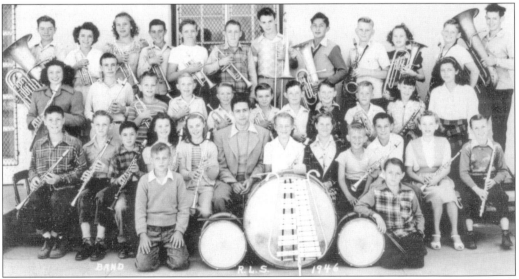

For many years, the Rio Linda Elementary School had a large band. This 1946 photograph shows, from left to right, (front drum section) Robert Rieb and Joseph Keeling; (first row) Donald Donsing, Donald Dill, Joseph Audre, Ida Mae Hunt, unidentified, Aubrey Penman (teacher), Lois Grimes, Janet Russ, Donald Posehn, Clarmont Brown, Lorraine Campbell, and Dennis Peterson; (second row) Wanda Axtell, Lloyd Day, Jerry ?, Lowell Brown, Donald Sabin, unidentified, Ralph ?, John ?, Verland Amundson, Joan Gross, Darryl Alhire, Tommy Hearst, Allen Weber, Edward Garcia, Monrad Monsen, Janet Chapman, Taylor Posehn, and Raymond Brown. (Courtesy Margaret Posehn.)

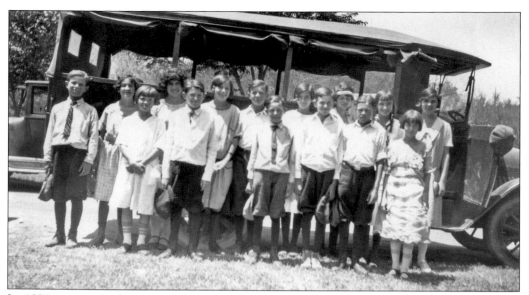

In 1924, essays on the extermination of flies were prepared by various grades in Rio Linda Elementary School and the winners (pictured here) were John Keiser, Clifford Curtis, and Ruth Haydock (fourth grade); Lewald Seifert, Evelyn Cooper, and Scoot Buckley (fifth grade); Stanley Wilson, Noma Chapman, and Mary Harris (sixth grade); Margaret Otterburn, Kermit Harris, and Fern Glick (seventh grade); and Helen Loucks, Charlotte Dike, and Louise Bohamera (eighth grade). The judges were Gladys Nevenzel, county demonstration agent; Mrs. J. W. Smith; and G. M. Mott. (Courtesy California State Library.)

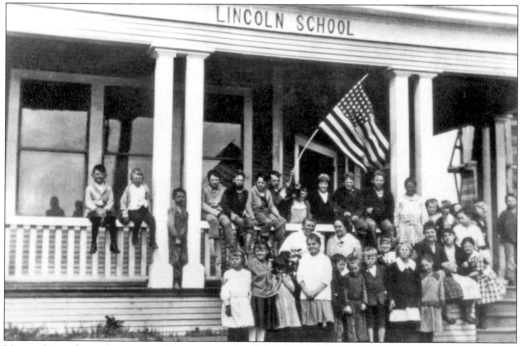

Victor Strauch made certain there was a school for the children in the Elverta area by donating the land where one could be built. The first school was called the Lincoln School, and this was one of its early classes. (Courtesy LeRoy Jordan.)

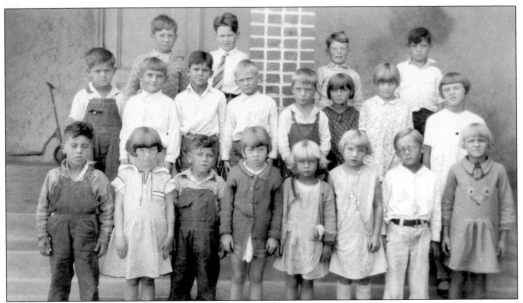

This was the Lincoln School class of 1931 in Elverta, which includes grades one through three. The students, from left to right, are (first row) George Zine, Elizabeth Baldwin, Ernie Zine, Patty Scheidel, Virginia Stillwell, Frances Scheidel, Darrell Orr, and Viola Meyer; (second row) Ralph Strauch, Fred Rinck, Louis Quint, Jim Jorgensen, George Gale, Olga Gale, Marian Reker, and Elizabeth Wellman; (third row) Elwyn Kerns, unidentified, Lawrence Baldwin, and Robert Bollinger. (Courtesy Marge Krans.)

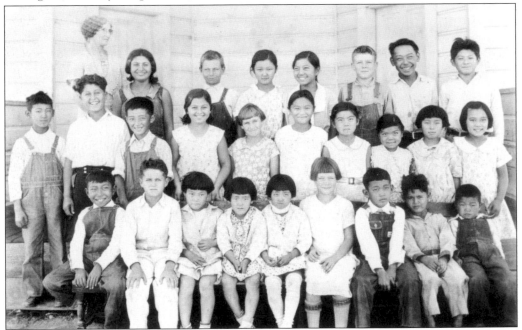

Before World War II and the attack on Pearl Harbor, there was a large population of Japanese in the Riego area, evident by number of Japanese students in this photograph of the Alpha School class in 1933. The girl in the middle row on the far right is Tsugi Sumihiro. (Courtesy Tsugi Sumihiro Makishima.)

Seven

FIGHTING FIRE

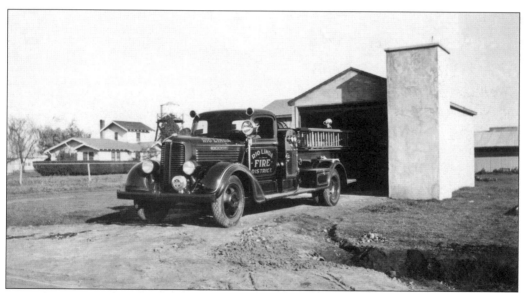

In 1923, the Rio Linda Fire Department formed. This building on Twenty-sixth Street, next to Chester Walsingham's home, was the first station to house a fire truck. Lester Thorn was the first fire chief, and there were 13 volunteers at the time. George Mott was instrumental in getting the fire department formed, and the first three fire commissioners appointed to act as the governing board were J. W. Smith, Dan Nash, and Paul Norbryhn. (Courtesy Randy Wooten.)

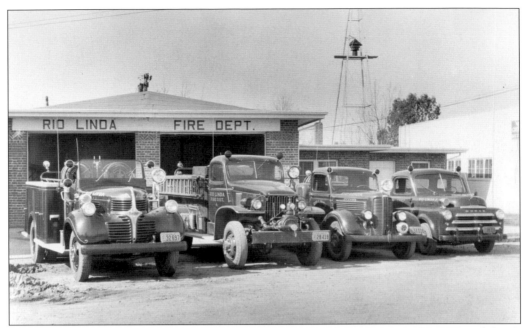

Station No. 1 in Rio Linda was located on Front Street, between Russ Grocery and Best's Garage. This photograph shows the station and three of the fire trucks housed there as well as the fire chief's pickup. (Courtesy Randy Wooten.)

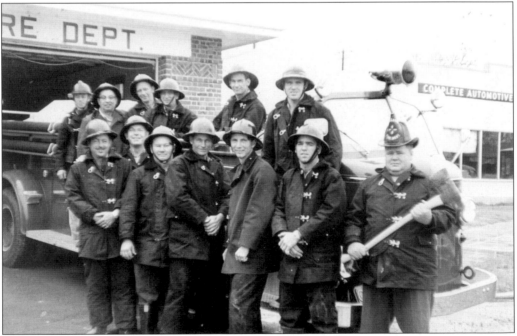

The part of the crew of Station No. 1 for Rio Linda Fire Department who served under Chief Best, from left to right, are (first row) Jack Stephens, Ivan McCurdy, Tex Rickard, Capt. Connie Gerolamy, Bill Yeargain, Harold Horrell, and Jerry Berg; (second row) Jimmy Welliver, Paul Penoff, Ralph Johnson, Richard Bolden, Lee Milwee, and Capt. Waldo Berg. (Courtesy Les Crane.)

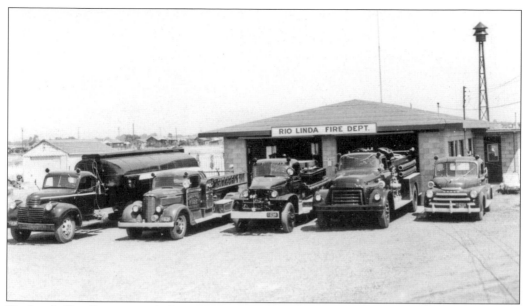

Rio Linda Fire Department's Station No. 2 was located on I Street in the Vineland area. The assistant fire chief, Les Crane, lived next door to the station. The department's water tanker was also kept at this station. (Courtesy Randy Wooten.)

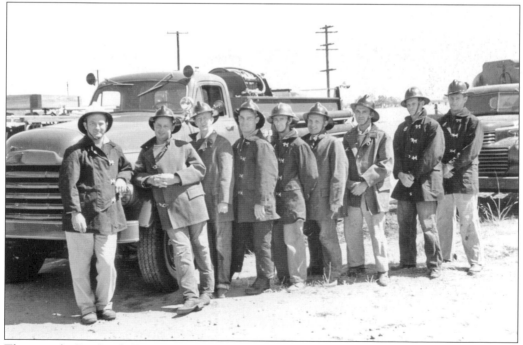

The crew for Rio Linda Fire Department Station No. 2, from left to right, are assistant fire chief Les Crane, Capt. Ted Hodel, Beryl Whitehead Sr., Mason Adams, Pete Hames, Herb Posehn, Capt. Virgil Rund, Jim Reed, and Capt. Rulon Glover. (Courtesy Les Crane.)

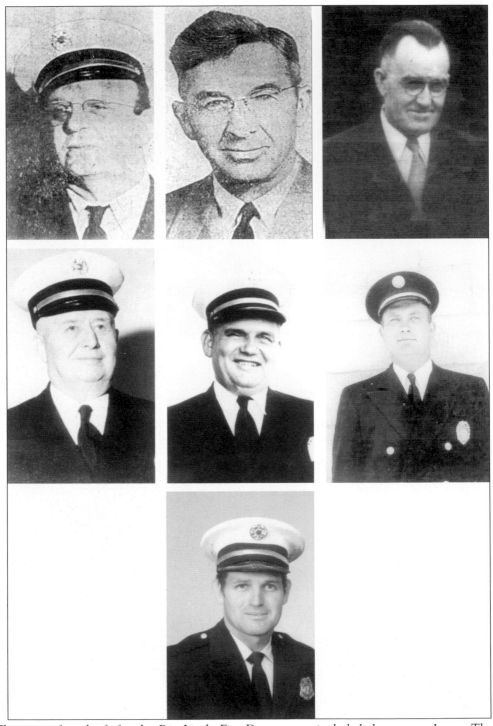

The seven fire chiefs for the Rio Linda Fire Department included these men: Lester Thorn (1922–1932), Everett M. Fisher (1932–1936), Elmer Fillback (1936–1938), Ray Gilmore (1938–1953), Clarence "Babe" Best (1953–1966), Lester Crane (1966–1975), and Ken Brown (1975–1990). (Courtesy Margaret Posehn.)

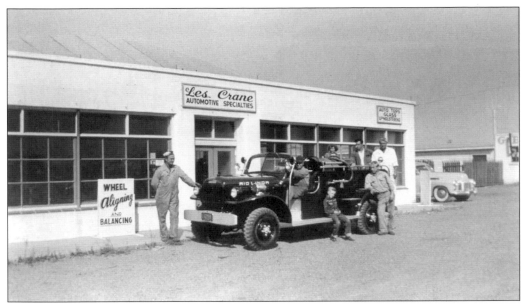

Les Crane owned and operated Les Crane Automotive Specialities on Eighth Street in Rio Linda. In addition to customizing cars, he also customized Rio Linda Fire Department Engine No. 7 in his shop. Les is the man leaning against the front of Engine No. 7. (Courtesy Rick Crane Jr.)

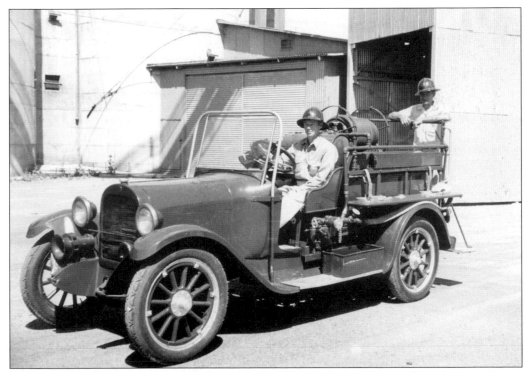

Old Betsy was Rio Linda Fire Department's first fire truck and she's still in the area, being maintained by Sacramento Metro Fire Department. This photograph shows Jim Welliver sitting behind the wheel and Connie Gerolamy on the back. (Courtesy Les Crane.)

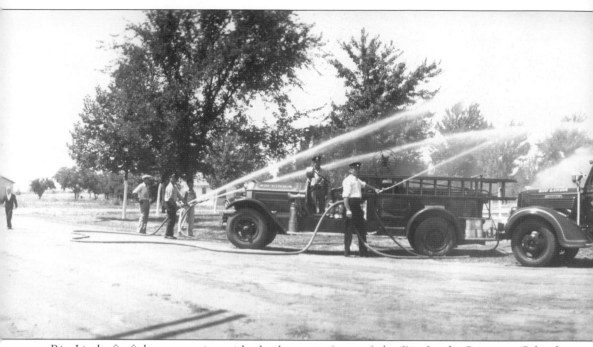

Rio Linda firefighters practice with the hoses in front of the Rio Linda Grammar School.

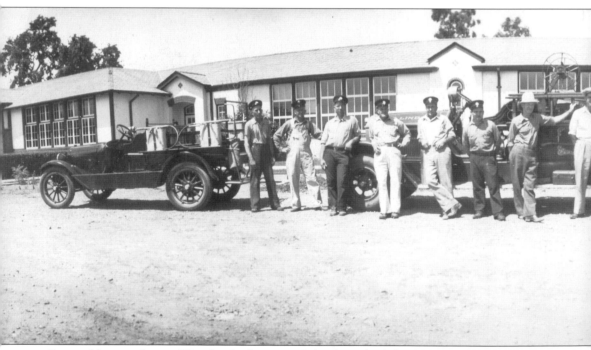

Pictured here in front of Rio Linda Grammar School are firefighters and three Rio Linda Fire Department trucks. The firefighters, from left to right, are Bert Taft, Ray Gilmore, Wilbur Donsing, Elmer Filback, Art Berg, Clarence Best, Leroy VanVooris, James Devine, Frank

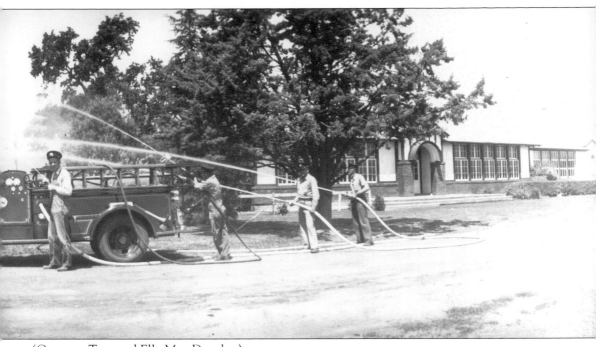

(Courtesy Tom and Ella Mae Douglas.)

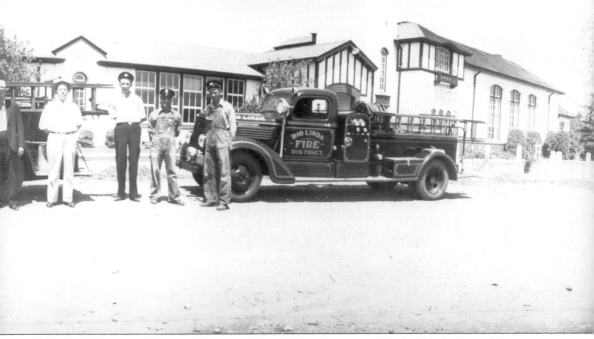

Hull, Ted Douglas, Monrad Monsen, Chet Walsingham, and Bob Sherfenberg. (Courtesy Tom Douglas.)

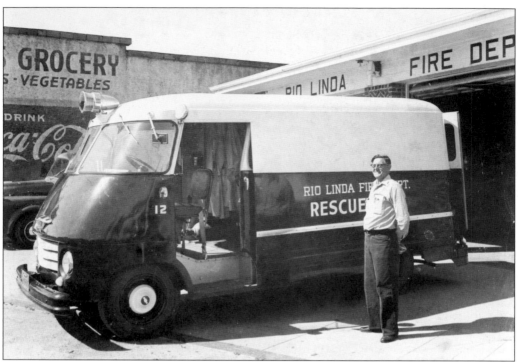

Ollie Gross stands proudly next to the rescue van that he used on calls for the Rio Linda Fire Department. Over the course of his career, Ollie assisted in the delivery of six babies. (Courtesy Les Crane.)

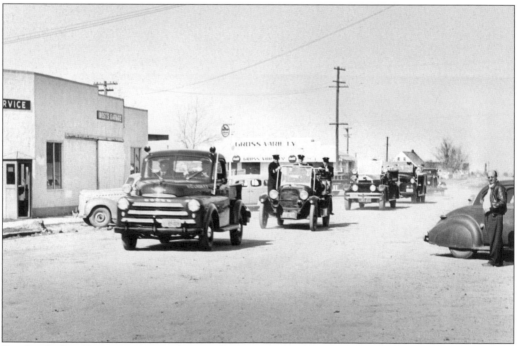

Rio Linda Fire Department trucks parade down Front Street towards the station with the fire chief in the lead, followed by Old Betsy. (Courtesy Randy Wooten.)

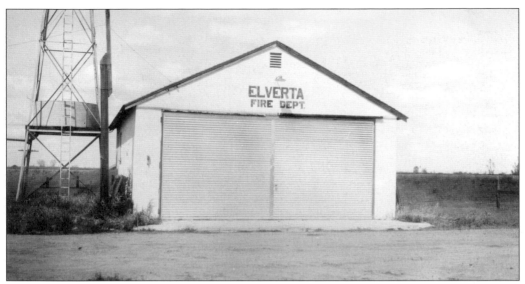

The first firehouse in Elverta was located on Rio Linda Boulevard and Elverta Road. The fire district was formed in 1926, and the first commissioners were Charles A. Anderson, Edward N. Stillwell, and Albert Scheidel. (Courtesy Randy Wooten.)

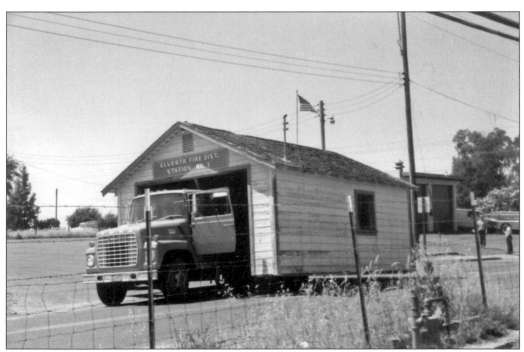

The old Elverta Station building is being hauled away to make room for a new building at the same location. (Courtesy Margaret Posehn.)

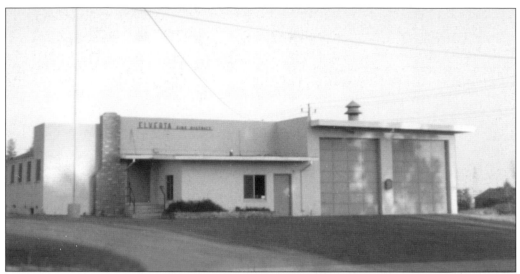

In 1944, a new Elverta Fire District was formed through the efforts of Charles Scheidel, Tom Collins, Wade Perry, George Anderson, John Mott, Erwin Brown, Walter Strauch, Clair Mortensen, and Frank Smith. This new building was constructed to house the fire trucks. A second station was set up at the home of Clair Mortensen on Elverta Road near Twenty-eighth Street. (Courtesy Margaret Posehn.)

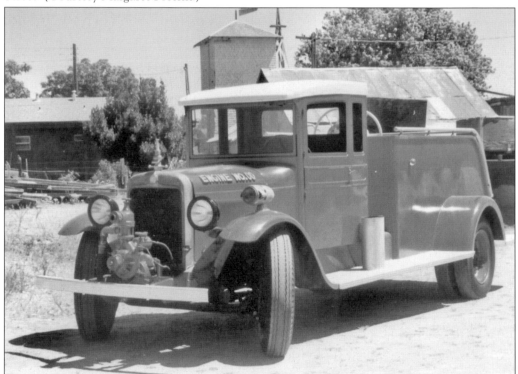

Elverta's Engine No. 00 was a 1930 Graham Dodge from PG&E in Rio Vista. The truck was modified for use by the department, but fireman Bob Bollinger complained that the pump on it was "one of the worst pumps made." It dripped all the time. The fire truck was recently restored by Laverne Scheidel. (Courtesy Margaret Posehn.)

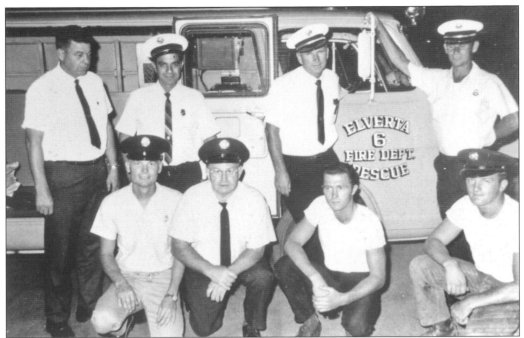

Members of the Elverta Fire Department's Rescue crew, from left to right, are (first row) Charles Mortensen, Fred Tice, Orville Wanner, and Don Wanner; (second row) Bob Bollinger, Clarence Zine, and two unidentified men. (Courtesy Marge Krans.)

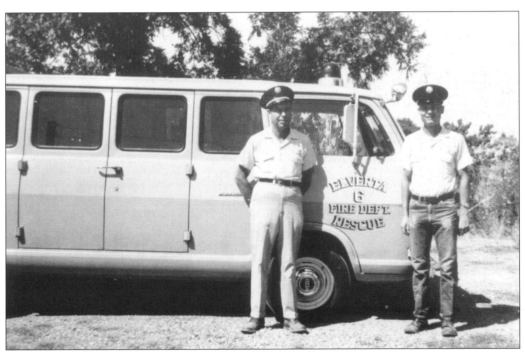

Pictured here are Clair Mortensen and his son Charlie with the Elverta Fire Department's rescue van. (Courtesy Marge Krans.)

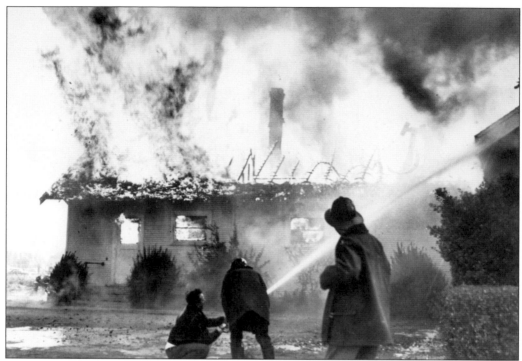

Rio Linda firemen are fighting the fire that destroyed the Rio Linda Community United Methodist Church on Sixth and M Streets. (Courtesy Roger Mitchell and Rio Linda Methodist Church.)

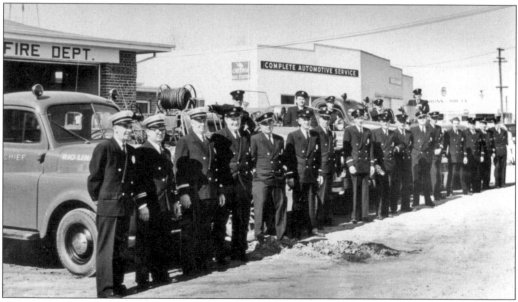

The Rio Linda firefighters in dress uniform pictured here are, from left to right, Chet Walsingham, Clarence Best, Ray Gilmore, Art Russ, Bill Gross, Lee Brown, Richard Bolden, Jack Klein (on the truck), Cecil Nash, unidentified (on the truck), Ralph Johnson, Ollie Gross, Frank Kral (on the truck), Tom Smith, Bob Winters, unidentified (on the truck), Connie Gerolamy, Charles Klein, Frank Monich, Paul Penoff, and unidentified. (Courtesy Wilbur Donsing.)

Eight

CHURCHES AND ORGANIZATIONS

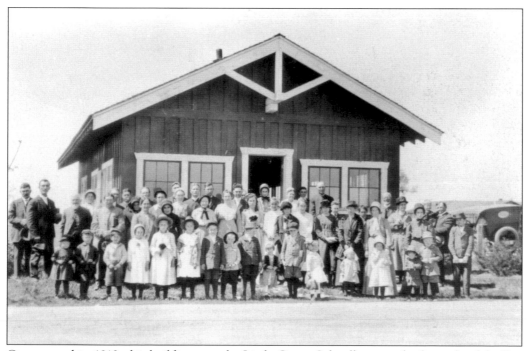

Constructed in 1913, this building was the Little Green Schoolhouse—the first school for Rio Linda. It also served as a community hall and a meeting place for the members of the Brethren church, assembled here for a photograph in 1920. (Courtesy John Lee Ernst.)

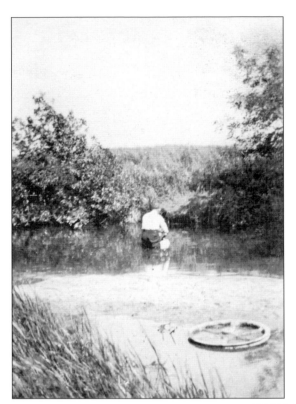

Members of the Brethren church used a wide section of Dry Creek for their baptisms. A member is being baptized here in 1921. (Courtesy John Lee Ernst.)

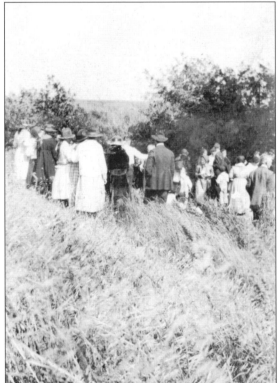

A baptism was a special occasion and members of the Brethren church gathered together to watch this 1921 event. (Courtesy John Lee Ernst.)

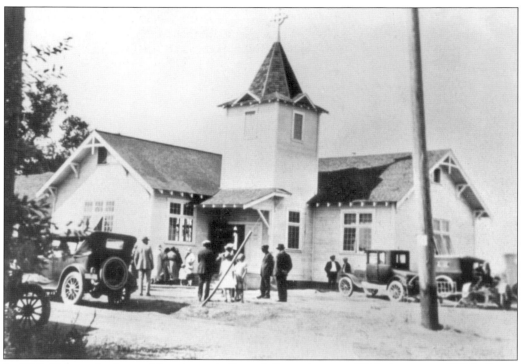

In 1923, Calvary Lutheran Church was built on L Street between Fifth Avenue and Fifth Street in Rio Linda. John Hodel was one of the contractors who worked on the new church. There was a large number of Scandinavian and German descendents in the area who welcomed a church of their faith. (Courtesy Margaret Posehn.)

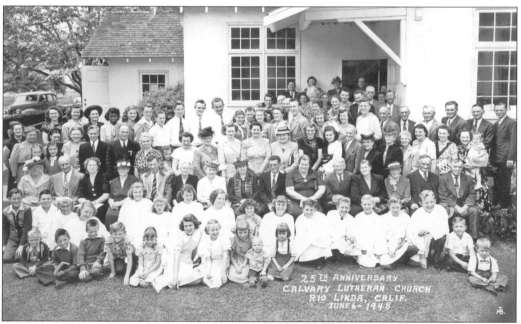

On the 25th anniversary of Calvary Lutheran Church (June 6, 1948), members of the congregation got together for a celebration and this photograph. (Courtesy Margaret Posehn.)

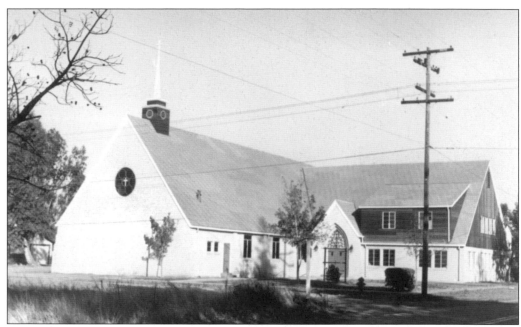

The Rio Linda Community United Methodist Church was completed in August 1918 on property donated by the Sacramento Suburban Fruit Lands Company. In June 1951, the church building caught fire and was totally destroyed. A new building, the one in this photograph, was constructed, and the first service in the new church was held on October 5, 1951. (Courtesy Marge Krans.)

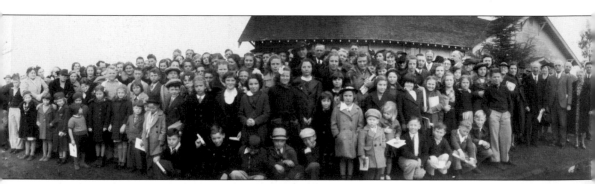

Members of the Rio Linda Community United Methodist Church gather together for this photograph prior to 1951. (Courtesy Tom and Ella Mae Douglas.)

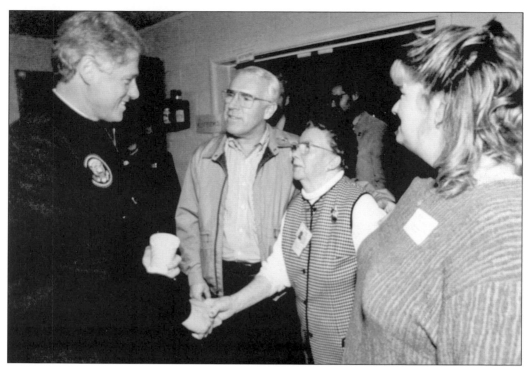

When Rio Linda experienced extensive flooding in the winter of 1995, it merited a visit by President Clinton. One of the stopping points for President Clinton was the Rio Linda Community United Methodist Church. He was accompanied by Congressman Vic Fazio, and in this photograph is greeting Elverta resident Wilma Dyer while an unidentified lady watches. (Courtesy Wilma Dyer.)

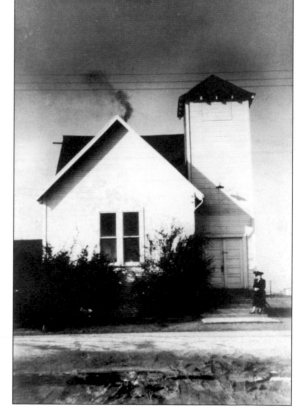

There is also a Methodist church in Elverta that is still going strong today. This photograph shows the original church built in Elverta, although it has been replaced by a newer building now. (Courtesy Marion Jorgenson.)

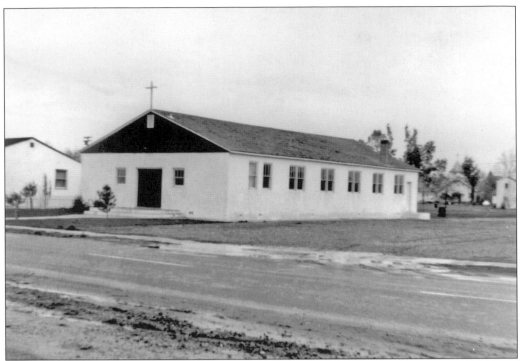

St. Anthony's Catholic Church was a welcome place for local Catholics, who were traveling to North Sacramento to attend church before 1948. (Courtesy Eloise Wagner collection.)

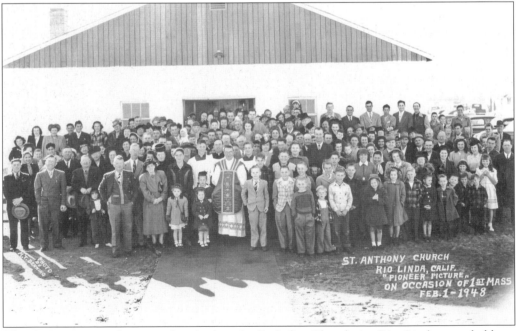

The first mass at the new St. Anthony's Catholic Church in Rio Linda was held on February 1, 1948. Here the congregation gathers for a photograph of the event. The only identified person in the photograph is the gentleman on the far left side, Charles Antl. (Courtesy Margaret Kaffka Garrehy.)

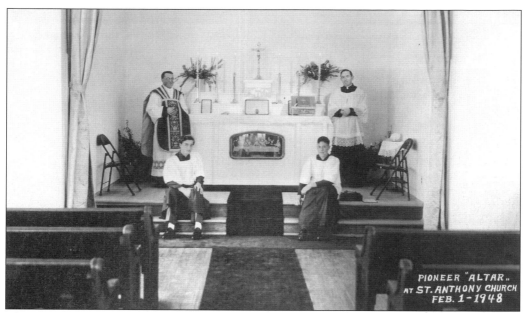

The altar and inside of St. Anthony's Catholic Church in Rio Linda is seen here. Completed in 1948, St. Anthony's was located on M and Fifth Streets. (Courtesy Margaret Kaffka Garrehy.)

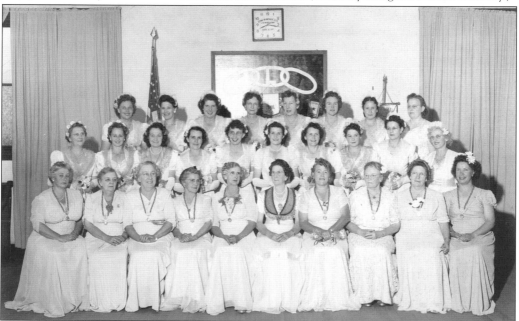

Rio Linda Rebekah's Lodge No. 378 poses for this photograph in the meeting hall above Horrell's Market. Pictured, from left to right, are (first row) unidentified, Laura Smith, Nina Chapman, Edith Forbes, unidentified, Vera Berglund, Nita Johnson, Florence VanVoorhies, Hanna Lazier, and Eileen Peterson; (second row) Ruth Spindler, Ann Pierce, Dorothy Griffith, Virginia Keeling, unidentified, Alice Gross, Margaret Corcoran, Frances Malone, Katherine Horrell, and Ellen Hall; (third row) Eleanor Russell, Grace Peck, unidentified, Roberta Pottenger, Helen Brainard, Margery Molland, Eloise Wagner, and Martha Hafner. (Courtesy Joan Gross Paul and Alice Gross.)

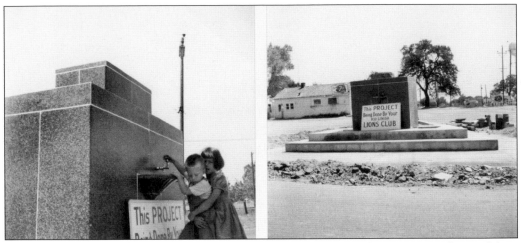

In the early 1950s, the Rio Linda Elverta Lions Club built Troy Park in memory of one of their members, who was killed while working during a storm. The small triangle located on M and Front Streets in Rio Linda has a monument with a drinking fountain and a plaque on which the names of all deceased members are listed. (Courtesy Carol Schulte Sherrets.)

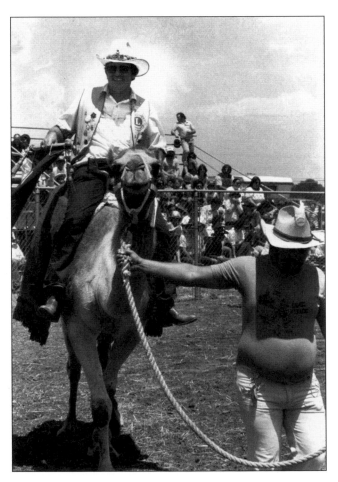

A rodeo is one of the annual fund-raising events hosted by the Rio Linda Elverta Lions Club each summer. In this photograph, Lion Bob Bastian rides a camel during opening festivities. (Courtesy Bob Bastian.)

Nine

ENTERTAINMENT AND RECREATION

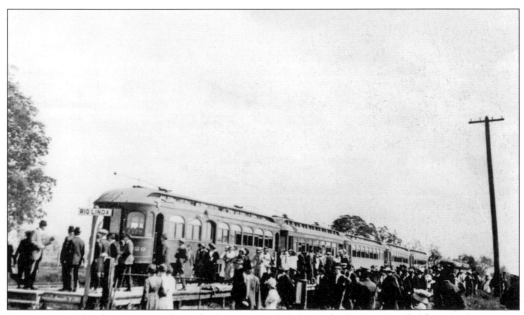

Sacramento Northern trains brought large crowds of people to Rio Linda during the spring of 1912 and 1913 to see all the California poppies in bloom. The fields of poppies lasted a few years during the early settlement of the area, but they disappeared as the town began to grow. (Courtesy Eloise Wagner collection.)

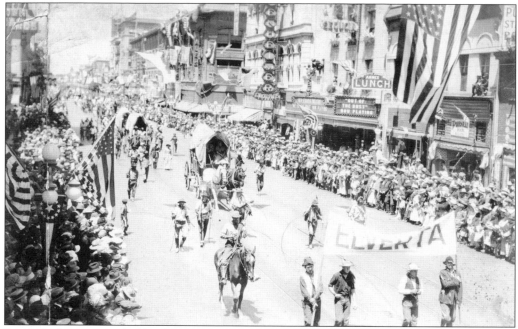

In 1922, Sacramento held a huge weeklong celebration for the anniversary of the discovery of gold in California. The area around the Southern Pacific rail yard was turned into a forty-niner camp, and people from all over the county came to participate in the parade and related events and don period clothing. This photograph shows the Elverta contingent in the parade. (Courtesy Florence Ross Wilhoite.)

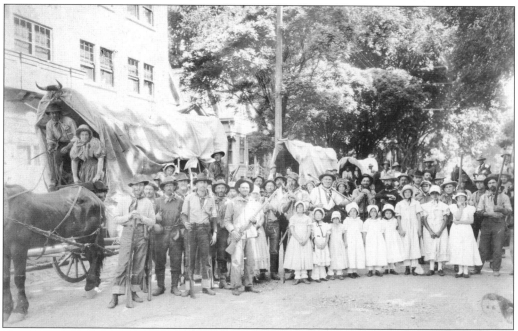

Elverta and Rio Linda participants in the Days of '49 parade gathered for this photograph. Young and old alike got into the action and made themselves look as authentic as possible. (Courtesy Florence Ross Wilhoite.)

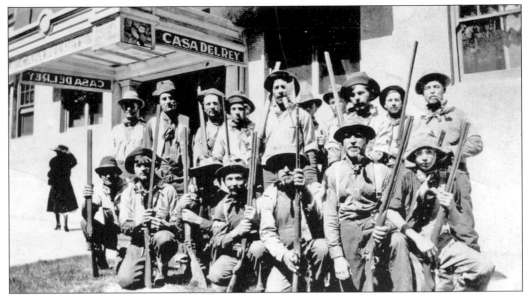

The men of Elverta took the Days of '49 celebration seriously and eagerly marched in the parade. This photograph includes George Puliz (first man from left kneeling), August Wolf (fifth from left kneeling), and Slim Carlson (sixth from left kneeling). Standing third from the left is Frank Smith and fifth from the left is Tom Ross. The rest are not identified. (Courtesy Florence Ross Wilhoite.)

Another group of men, this time from Rio Linda, help celebrate during the Days of '49. (Courtesy John Lee Ernst.)

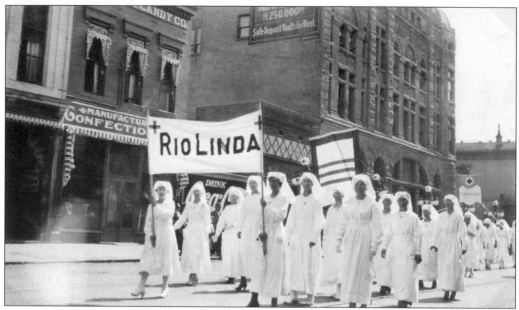

In 1919, the Rio Linda Red Cross women participated in the Armistice Day parade in Sacramento. Nina Chapman was one of the women in the parade. (Courtesy Sam and Nina Chapman collection.)

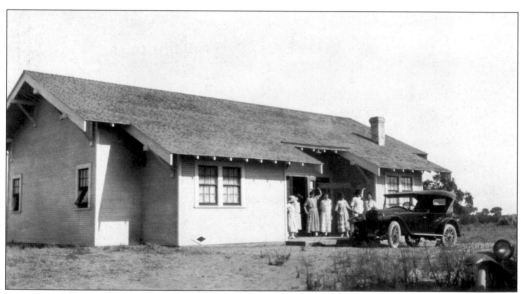

In November 1922, construction of the Rio Linda County Club was completed on property donated by the Sacramento Suburban Fruit Lands Company. Dances or card parties were held on alternating Friday evenings. The American Legion Hall now stands on this site. (Courtesy Margaret Posehn.)

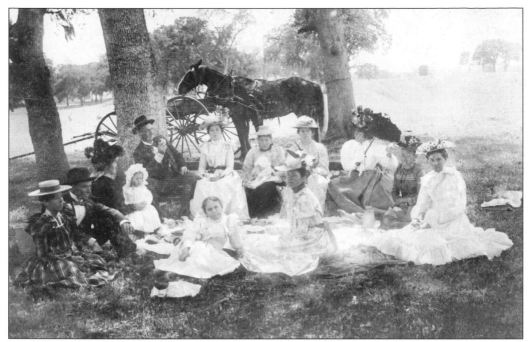

A picnic takes place at Chatterton's Grove, probably before 1900. The lady wearing a black skirt and holding a baby is Anna Harms Wait, and to her left is Elizabeth Harms Stahl. Chatterton's grove of oak trees was located near Dry Creek, where it forks and forms Cherry Island. It was on the border of Antelope and Elverta. This area is now the Cherry Island Golf Course. (Courtesy Kenna Wait Boyer.)

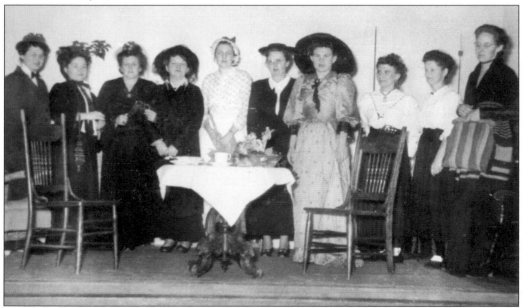

Elverta ladies had their own social club, The Mother's Club, which put on a play at the Elverta School around 1945. Pictured, from left to right, are unidentified, Edwina Crews, Vera Maakstead, Una Mae Qulick, Muriel Smith, Mrs. Underwood, Helen McKenzie, Hilda Holt, Ina (Toots) Perry, and Edna Duncan. (Courtesy Helen McKenzie.)

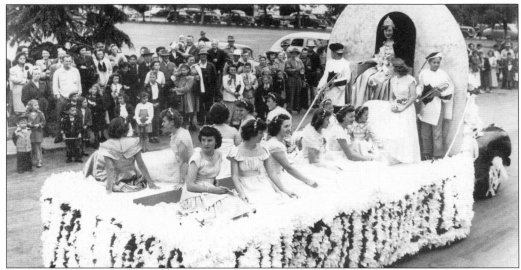

The Rio Linda Chamber of Commerce organized the 1950 and 1951 Chick and Egg Festival, which included a parade, awards, a horse show at Harris Arena, an outdoor dance, boat rides on Dry Creek, and, of course, chicken to eat. The parade float pictured here carries the event queen, Nadine Forbes (who won by selling the largest number of tickets), and to her left is Norma Horrell. The other beauties, starting from Norma and going towards the end of the float, are Carol Schulte (daughter of Barbara), Barbara Griffith, Cynthia Dronberger, Barbara Bolden, Barbara Schulte, Nancy Sabin, and unidentified. The five ladies in the back are Joan Gross, Frances Libsack, Joyce McCreary, Joan Taylor, and Betty Davis. (Courtesy Norma Horrell.)

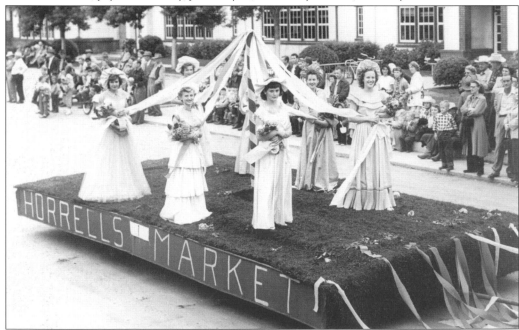

Horrell's Market sponsored this float carrying more of the local beauty for the 1951 Chick and Egg Festival. The ladies here, starting on the far left and going counter-clockwise, are Patty Horrell, Inez Baker, Marlene Hayer, Katherine Horrell, Nancy Horrell, unidentified (almost out of sight), and Hope Schlax. (Courtesy Norma Horrell.)

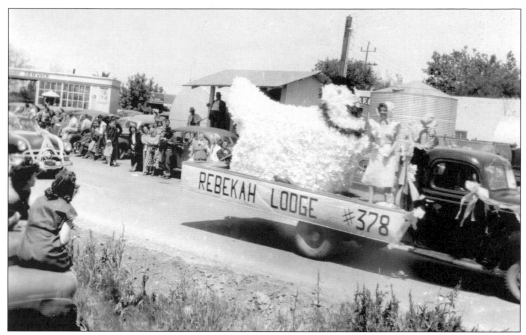

A huge chicken made up the float for Rebekah Lodge No. 378 in this parade. The original Chick and Egg Festival lasted for only two years. It was revived in 1957 by the Rio Linda Community United Methodist Church as a fund-raiser and renamed the Chik N Q. It continued each year for over a decade on the Fourth of July. (Courtesy John Lee Ernst.)

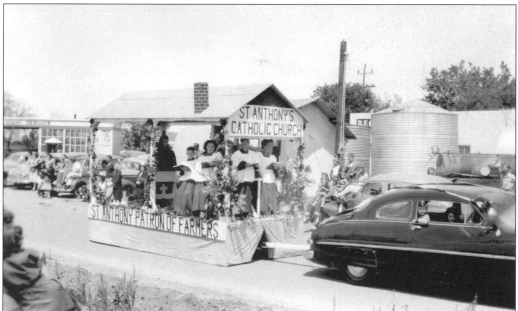

St. Anthony's Catholic Church also participated in the Chick and Egg Festival with their parade float. Whenever possible, a Babe Ruth baseball game was scheduled for the afternoon and there were various contests, including potato races, short dashes, three-legged races, and horseshoe pitching. Winners received awards, increasing the keen competition. (Courtesy John Lee Ernst.)

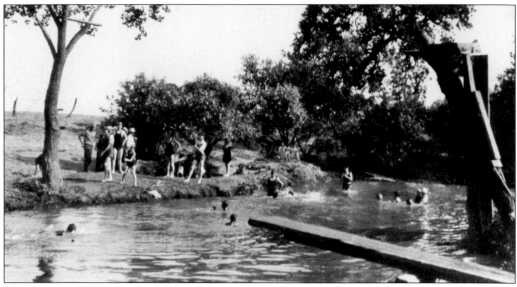

The Sacramento valley has plenty of hot summer days, and residents of Rio Linda enjoyed swimming in the local watering hole, known as the Ambrose Swimming Hole. This was not far from the railroad tracks of the Sacramento Northern Railway and local teenagers would often show off as the train went by, especially if they were skinny dipping.

The need for a public swimming pool was filled in July 1927 by Frank Smith when he built a large pool in Elverta on the north side of Elverta Road, again by the railroad tracks. The 40-foot by 80-foot pool was filled with well water and was drained and refilled every 48 hours in a 10-hour process. It was advertised in local papers as the "Elverta Baths," as evidenced in this ad. (Courtesy Jim Smith.)

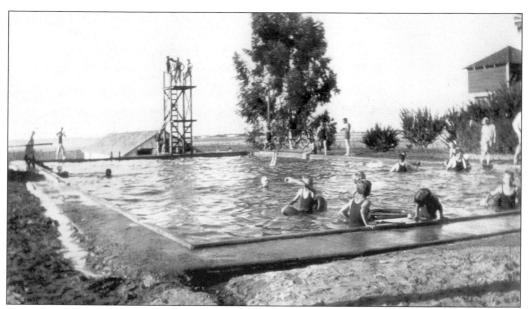

The Elverta Plunge (formerly Elverta Baths) was dug by hand and featured a high diving board. Some years later, a smaller wading pool was added for very young children. There were dressing rooms on the right side and later, tables. Local organizations often held parties at the plunge. One group got so rowdy the fire department was called in to hose them down. The facility was fenced in a short time later. (Courtesy Wilma Dyer.)

Local swimmers at the Elverta Plunge included Jose Smith, Anna Brecker, Wilma Reker, Shirley Scheidel, Betty Christiansen, Helen Scheidel, and Patty Hoyt. (Courtesy Helen McKenzie.)

Baseball was a favorite pastime in Rio Linda and Elverta. This team, representing the local American Legion Haggin-Grant Post 521 on a Sacramento County League, was playing Folsom Prison. The team includes, from left to right, (first row) unidentified, a Folsom Prison guard, Mark McCormick, Harold Kiser, and unidentified; (second row) Enoch Stewart, unidentified, Earl Kiser, Clarence Weisgerber, and Clarence (Babe) Best (who was later a fire chief for Rio Linda); (third row) Warren Blodgett, Ray Sisler, Kenny Sisler, Rick Erickson, and two unidentified. (Courtesy Tom Best.)

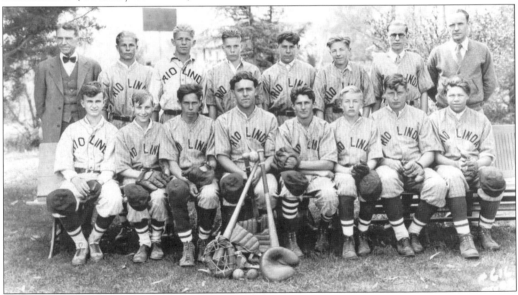

Little is known about this early Rio Linda baseball team, but it was probably a forerunner of the Little League that began in Rio Linda in 1957. Little League in Rio Linda and Elverta is quite large today, with enough teams to hold an hour-long parade every year. Each team has its own float in the parade, and in recent years, boxes and boxes of candy are tossed out to observers. (Courtesy Margaret Posehn.)

The rural lands of Rio Linda and Elverta enticed many residents to have horses, and horseback riding is just as popular today as it was years ago. Marvel and Ruby Harris lived on Curved Bridge Road and Tenth Street and had a small horse arena. They are pictured here with some of their prize-winning horses. (Courtesy Ruby Harris.)

Ruby and Marvel Harris are pictured here riding two of their horses. Their horse shows attracted quite a number of riders and were spectacular displays for fine horsemanship. (Courtesy Ruby Harris.)

Peter Posehn, a native of Davin, Saskatchewan, Canada, sits proudly in his Model T Speedster, a handmade car built on a Model T chassis from 1919 to 1923. While many of Pete's relatives were busy in the poultry business, Pete chose another profession and worked first for Mendenhall Sheet Metal Works in Sacramento, and later for Dunphy Sheet Metal Products. (Courtesy Margaret Posehn.)

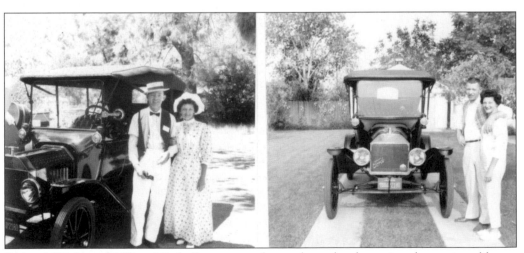

Richard (Dick) and Lillian Mitchell were one of several couples that enjoyed restoring old cars, driving them in parades, or going to car shows. The Mitchells often joined fire chief Les Crane and his wife, Jewel, in these events, and Dick and Les often worked on cars together. (Courtesy Roger Mitchell.)

Motorcycles were also a favorite past time for some of the local residents. In 1946, Jim Krans, left, sits on his Indian motorcycle. For almost a decade, he was a chicken rancher. He then went into the water well drilling and pump work business. Les Crane, right, rode his motorcycle from Washington to Sacramento and stayed. He opened an automotive shop in Rio Linda, became a fireman for the Rio Linda Fire Department, and was later named fire chief. (Courtesy Marge Krans and Sharon Freitas.)

The residents of the Rio Linda and Elverta communities have been a fairly close knit group of people, probably because so many families were related to each other. The Chapman sisters (daughters of Sam and Nina Chapman) and a few of their friends decided to have annual get-togethers over lunch, and soon others began to join them. This became the Early Timers' Luncheon held each fall, and when the Chapman sisters gave up holding the luncheons, it was taken over by Wilbur Donsing. When Wilbur passed away, Julia Jochim took the job of coordinating the event. This photograph of "Early Timers" includes Mary Harris, Naomi Whipple Smith, Gladys Nash Burrows, Phoebe Jones Shaul (their schoolteacher), Cecilia Matushak, Otto Dicks, Edra Chapman Larson, Noma Chapman Gerolamy, Harry Whipple, Helen Chapman Brainard, Alice Reemts Gillenwaters, Lee Whipple, and Wilbur Donsing (seated). (Courtesy Marge Krans.)

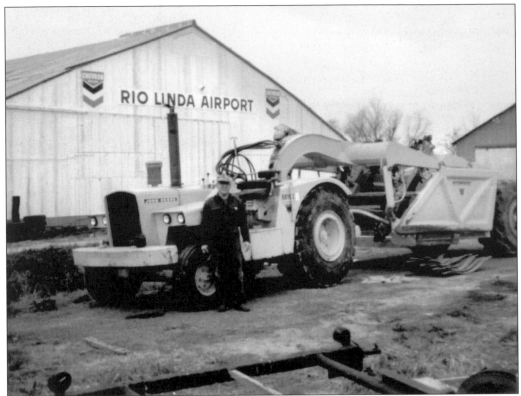

Elverta and Rio Linda had several small, private landing strips, mostly owned by local farmers for their personal use. The landing strip on Dry Creek Road was owned by Roy Hayer. He later moved it a short distance away, closer to Dry Creek, and started Rio Linda Airport. It became a popular place for private pilots and was later sold to Mauser Aviation. Today there are about 90 hangers and well over 100 private planes at the airport. (Courtesy Marlene Hayer Bastian.)

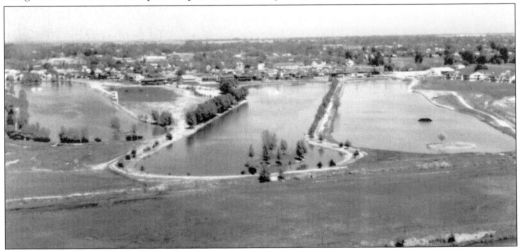

A 17-acre piece of land was excavated by Roy Hayer to provide enough soil to raise the runway for Rio Linda Airport. Naturally, the excavated area south of the airport became a lake during the winter. A company called Bell Acqua purchased the land and made three lakes for world-class waterskiing events. (Courtesy author.)

The Rio Linda/Elverta Historical Society was formed in 1991 by a group of people anxious to preserve the history of these communities. While striving to preserve the history, the society endeavors to give back to the community in many ways. A two-day annual Farm and Tractor Days event is held each year in May, with the first day (Friday) devoted to schoolchildren. Between 900 and 1,000 schoolchildren attend that day and participate in crafts, watch the tractors work, and learn about the area's early history. (Courtesy Marge Krans.)

The Early Day Gas Engine and Tractor Association, Branch No. 13, is the primary participant in the annual Farm and Tractor Days event. Their members come from all over California to show off their tractors and to have fun using their equipment in the adjoining field. Many of the members bring their old gas or steam engines and operate them during the event. (Courtesy Margaret Posehn.)

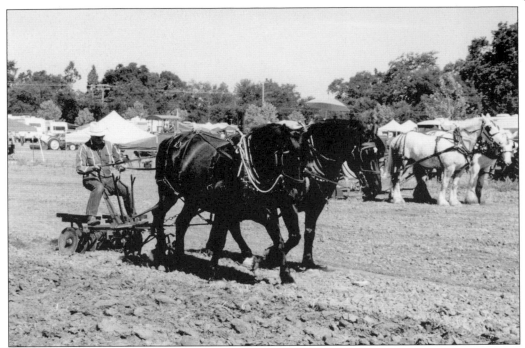

In 2005, for the first time in the history of the Farm and Tractor Days event, the Golden State Draft Horse and Mule Club participated. They brought six teams of horses and mules and showed off their ground-working skills for all who attended. (Courtesy Bob and Carol Foley.)

The Rio Linda High School Junior ROTC is another regular participant in the annual Farm and Tractor Days event. Each year, the ROTC performs a morning flag-raising ceremony and afterward their members help with parking event attendees. Uncle Sam (Maynard Buckland) joins the ROTC for this photograph and proudly participates in the ROTC awards ceremony at Rio Linda High School.